THE NATIONAL GALLERY

THE ART OF WORSHIP

PAINTINGS, PRAYERS, AND READINGS FOR MEDITATION

For Helen,
and David, Timothy, Sarah and Philip
who grew up in Trafalgar Square.

THE NATIONAL GALLERY

THE ART OF WORSHIP

PAINTINGS, PRAYERS, AND READINGS FOR MEDITATION

THE REVEREND NICHOLAS HOLTAM

Vicar of St Martin-in-the-Fields, London

National Gallery Company, London
Distributed by Yale University Press

First published in Great Britain in 2011 by
National Gallery Company Limited
St Vincent House · 30 Orange Street London WC2H 7HH
www.nationalgallery.org.uk

ISBN: 978 1 85709 531 9
1032035

British Library Cataloguing-in-Publication Data.
A catalogue record is available from the British Library.
Library of Congress Control Number: 2011924913
Publishing Director: Louise Rice
Publishing Manager: Sara Purdy
Project Editors: Rachel Giles and Claire Young
Editors: Alysoun Owen and Jill Laidlaw
Picture Researcher: Maria Ranauro
Production: Jane Hyne and Penny Le Tissier
Designed by Vermillion Design, Dublin
Printed in Spain by Grafos

**National Gallery publications generate valuable revenue
for the Gallery, to ensure that future generations are able
to enjoy the paintings as we do today.**

Front cover: Piero della Francesca, *The Baptism of Christ*, 1450s.
Back cover: Titian, *The Tribute Money*, 1560–8;
Pieter de Hooch, *The Courtyard of a House in Delft*, 1658

CONTENTS

FOREWORD

RICHARD CHARTRES, BISHOP OF LONDON

Many of the paintings in the National Gallery were inspired by stories from the Christian scriptures, once well-known but now only rarely part of our contemporary mental furniture. Nicholas Holtam enhances our enjoyment of some of the best-known pictures in the Gallery by alerting us to the details that reveal the depth of association and the reverberations within the canvas.

At a time when we are saturated by words, which can easily become threadbare and hackneyed, contemplating a picture can give us fresh insight in the perennial themes which are part of any human life. Nicholas Holtam leads us on a visual pilgrimage in brief meditations which are the fruit of the closer relationship between St Martin-in-the-Fields and the National Gallery which he has done so much to develop.

I have learnt fresh things about paintings I thought I knew well and I hope that others will find like improvement and delight in these pages.

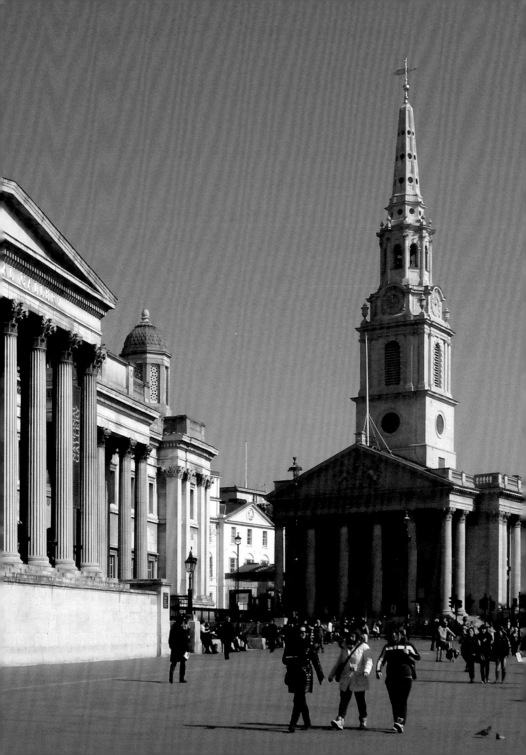

INTRODUCTION

NICHOLAS HOLTAM, VICAR, ST MARTIN-IN-THE-FIELDS

The National Gallery and St Martin-in-the-Fields are neighbours on the north side of Trafalgar Square in the heart of London. The main business of the Gallery is art and that of a parish church is worship. There are striking connections. About a third of the Gallery's paintings are of Christian subjects. Many of them were painted as devotional pieces for sacred spaces such as chapels and churches or for private devotion in homes. They are a crucial part of our cultural heritage. The paintings carry the Christian stories from one generation to the next and they show how each generation interprets these stories afresh.

They help us to reflect on our material life and to explore the connection between God and humanity, beauty and holiness, the possibilities of love and the age-old problems of wickedness, pain and suffering. The Gallery is a reflective space. In the sense of it being set apart, it is holy. In some ways the Gallery can be an easier space in which to pray than the busy church across the road, perhaps because it is so open and demands nothing in terms of our personal commitment or beliefs. It does, however, inform, inspire, support and challenge us about what we believe and how we live.

Throughout the 20th century St Martin's was known for its practical and hospitable Christianity. Since 1916 it has been called 'The church of the ever open door', a title which embodies vision but always risks disappointment. It has engaged with the moral and spiritual issues of the day. In 1924 the first religious broadcast of a church service came from St Martin's, making a link with the BBC that continues today. It is the church where Amnesty International came to the mind of its founder. With South Africa House as its other neighbour, St Martin's was a key support to the anti-apartheid movement and now of South Africa's new rainbow nation. St Martin's knows the

significance of what was taught by the 2nd-century French bishop Saint Irenaeus, that the absence of paradox is the mark of heresy. St Martin's is the Admiralty's parish church and the church associated with the founding of the Peace Pledge Union, the British Pacifist movement. Named after one of the patron saints of France, it sits in the corner of the square named after Britain's greatest naval victory over the French. St Martin's is the Royal Parish Church and the church of many of those who are homeless and have slipped through the safety nets of British society.

Homelessness is not a single issue and most of those who turn to St Martin's for help have experienced some mix of unemployment, poverty, mental illness, addiction and the breakdown of relationships, as well as homelessness. Practical help is vital and The Connection at St Martin's provides food, showers and the opportunity to wash clothes as well as opportunities for counselling, education and help towards finding and keeping accommodation and work. What matters most is that people's self-esteem grows and they gain self-confidence. The art group provided by The Connection is one place in which this is built by making something which in itself is beautiful and therapeutic and which when displayed receives applause so that our homeless artists stand a little taller. Their visits to the National Gallery are immensely valuable and part of the Gallery's commitment to education and access for all.

Thirty years ago I was a curate in Stepney in London's East End. The first group of youngsters I prepared for confirmation were not very good at reading and writing. I struggled with how to engage them with the Bible and the wealth of Christianity's historic resources. We came to the National Gallery and looked at two paintings of the nativity of Christ: one of shepherds come to worship the infant in a stable (page 21), the other of magi bringing gifts of gold, frankincense and myrrh (page 23). For these youngsters the visual opened the scriptures as we entered two of the Gospels, Luke and Matthew, through art. We began to see how the books contained distinctive pictures of Jesus and what emerged from the collection of books in the Bible was a rich and real account of God among us.

Most of us can find worth and meaning in art. People often speak of losing themselves in a painting or work of art, preoccupied by something or someone beyond the self. This experience does not just belong to the overtly 'religious' but is the common experience of what it is to worship. In losing our self-centred selves we find ourselves in relationship to one another, the wide earth and the creator. It happens in an art gallery as it does in church.

In Iris Murdoch's novel *The Bell*, Dora Greenfield visited the National Gallery rather unintentionally but as she had done a thousand times before. She felt calm as she walked among the familiar pictures.

> She could look, as one can when one knows a great thing very well, confronting it with a dignity which it has itself conferred. She felt that the pictures belonged to her, and reflected ruefully that they were about the only thing that did. Vaguely, consoled by the presence of something welcoming and responding in the place, her footsteps took her to various shrines at which she had worshipped so often before …
>
> The pictures were something real outside herself, which spoke to her kindly and yet in sovereign tones, something superior and good whose presence destroyed the dreary trance-like solipsism of her earlier mood. When the world had seemed to be subjective it had seemed to be without interest or value. But there was something else in it after all.

Filled with love for the pictures, their authority, their marvellous generosity, their splendour, Dora experienced a kind of revelation. She felt the need to go down on her knees, as it were embracing a painting and shedding tears. It was an act of worship.

The choice of paintings for this book, and the words written about them leading to a prayer, provide starting points and suggest a method to encourage you to look for yourself at the pictures and to think about and pray them. There are biblical quotations and references but you may find it helpful to have a Bible to hand so you can read the stories in their contexts. The New Revised Standard Version has been used throughout.

This book divides into three sections, beginning with *Praying the Scriptures*. The Christian Bible is a collection of 66 books divided by the birth of Jesus Christ. Those books from before Jesus, the Hebrew scriptures, were written across a period of a thousand years or so. Those from after the birth of Jesus were written in a form of ancient Greek during the first hundred years or so of the Church. The Bible can seem a difficult text but it has inspired and shaped the lives of countless individuals and the culture of a substantial part of the world, including Western Europe and the artistic tradition collected in the National Gallery. *Praying the Scriptures* is the obvious territory for a prayer book of the National Gallery, making the connection between art and worship.

The second section is *Prayers of the Church*. So many prayers are passages of scripture that there is inevitably an overlap with the first section but the distinction is that these paintings and prayers are from the Church's worship, life and service. They explore aspects of discipleship and Christian devotion and they suggest that it is in worship that we find our true nature and the implications for the way we live with and for one another.

The first two sections are crucial to the formation of the Christian person, and they are basic to my life as a Christian priest, but for me the most fun in writing this book was with the third section, *Prayers in the World*. If God exists, God exists in the world, not just the Church. Therefore the task of the Christian is to live in response to God in Jesus Christ in the wide, glorious and diverse world. This is life's great adventure and the paintings help to explore some themes. The selection is idiosyncratic, a mix of important ideas with what for me are favourite pictures and prayers.

In a time of rapid change the great traditions of theology and art are sources of understanding, knowledge and wisdom. They evoke faith, hope and love, the three things said by Saint Paul in 1 Corinthians chapter 13 to be eternal and without which life becomes so much noise and strife. We can learn from these traditions and I also hope that the paintings, reflections and prayers will expand

our imagination to the glorious possibilities of God's world. What Christians seek is to be people alive to the presence of God.

Being the National Gallery's parish priest is one of the greatest privileges of being the Vicar of St Martin-in-the-Fields. I am grateful for the good neighbourliness of many of the Gallery's staff and for shared life and friendships over the last 16 years. Both the church and the Gallery are lively parts of our cultural heritage. It is a point of principle for both that access is free. This makes it possible for people to drop in, perhaps only for a few minutes, to say a prayer or look at a painting.

St Martin-in-the-Fields has recently undergone a major buildings renewal project, equipping it for service in the 21st century. As well as a thriving church with English- and Chinese-speaking congregations, St Martin's is a centre for charity, helping people in need all over the country. We care for 6,000 homeless people every year and have a Chinese people's Day Centre. There is a hospitable café and an increasingly important creative programme of music and art. The new window and the proposed altar by Shirazeh Houshiary and other commissions have engaged the worship of the church with contemporary art. The buildings renewal at St Martin's has recovered that connection between ethics and aesthetics, the beauty of what is good, true and holy.

Thou that hast given so much to me, Give one thing more, a grateful heart. See how thy beggar works on thee By art.

Gratefulnesse,
GEORGE HERBERT
(1593–1633)

In one of the greatest accounts of Anglican moral theology in the 20th century, *The Vision of God*, Kenneth Kirk suggested that the words 'disinterestedness' or 'unselfishness' express the ideal of Christian character. Kirk says it is of the essence of Christian ethics that no form of self-centredness can truly be called disinterested and therefore the first practical question of Christian ethics is how can unselfishness be attained? His answer is the way of worship, which lifts the soul out of its preoccupation with itself and its activities, and centres its aspirations entirely on God.

Both the church and the National Gallery help us to find our place with God and one another by drawing us into the art of worship, which is the purpose of this book.

Listen with the ear of your heart
SAINT BENEDICT (480–547)

THE BIBLE

The Bible is the world's number one best-seller. It is a collection of 66 books written across a period of a thousand years. The Hebrew scriptures from before the birth of Jesus are the Old Testament. The New Testament, consisting of the Gospels, letters and other books of the earliest Church, was written in an ancient form of Greek. More like a library than a single book, the Bible presents God to us in a variety of literary styles such as history and story, myth and allegory, poetry and imagery, prayer and praise. The Bible is also one of the most abused books in the world. Passages are quoted out of context and used authoritatively in support of a thousand madcap ideas. Yet the Bible has an astonishing capacity to fire and enliven us, to judge and purify. Time after time it changes the lives of individuals and communities. It has shaped the lives of the rich and powerful as well as the lives of people who have nothing.

In the late 4th century, Saint Jerome translated the Bible from its original Greek and Hebrew into Latin. Often he is shown accompanied by a lion because he was said to have removed a thorn from a lion's paw in the Judean desert. In this painting the animal conveys a sense of peace and of being at one with all creation. Biblical scholarship and its translation for others is hard work. For Jerome, head in hand, this inspired process, with Christ on the cross hovering over, looks in keeping with the adage of most great tasks being 90 per cent perspiration and 10 per cent inspiration. The light is striking and is particularly noticeable on the cupboard doors, left open during this engrossing task. Other items are abandoned to Saint Jerome's work, such as the cardinal's hat, a badge of high office left casually on the floor.

The Bible exists to bring us to God. In this painting Saint Jerome has removed his shoes for he is on holy ground. Looking at this painting and reading the Bible, so are we.

O Lord, you have given us your Word
for a light to shine upon our path;
inspire us to meditate upon that word,
and to follow its teaching,
that we may find in it the light that
 shines more and more,
until the perfect day,
through Jesus Christ our Lord. Amen.

SAINT JEROME (about 347–420)

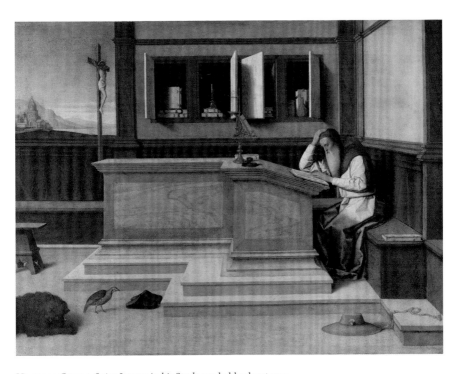

Vincenzo Catena, *Saint Jerome in his Study*, probably about 1510

BEING HUMAN

Adam and Eve stand between the Tree of Knowledge of Good and Evil and the Tree of Life. Adam has just tasted the apple that Eve holds, while the serpent watches from above. In the background is the Garden of Eden with the richly decorated Fountain of Life in the centre.

There are two creation stories in the Book of Genesis. Having been told the story of creation in six days in Genesis chapter 1, there is the story of Adam and Eve in the Garden of Eden in Genesis chapters 2 and 3. That there are two creation stories makes it clear we are not dealing here with science or history but with an exploration of what it is to be human. In Hebrew Adam means 'man' and Eve is linked with the word for 'life' and a similar Hebrew word meaning 'snake'. We are creatures tempted to want to be like God. We find it difficult to take responsibility for ourselves and, when found out, are prone to hide and pass the blame. Adam blames the woman for tempting him with the forbidden apple, she blames the serpent for tricking her. No scientific account of human nature could convey so well their feelings of guilt and shame. Banished to a place east of Eden they are consigned to a life of toil with a memory of paradise and a hope of heaven. Adam and Eve are everyman and every-woman, realistic, solid and muscular.

When we pray we place ourselves consciously where God can see us. Unlike Adam and Eve, who hid among the trees in the garden for fear of being found out, prayer begins with our recognition that we stand in the presence of God. In doing this we take responsibility for ourselves so that we find ourselves in relation to the creator and creation.

Rather than dwelling on human wickedness, some Rabbinic traditions of Judaism suggest that at the end of our lives God will first ask us whether we enjoyed the creation. To be conscious even for a moment in this vast expanding universe is simply wonderful.

O God of the heavens and the earth, of the astronomical and the subatomic, of the living and the dead, of science and history, of life and love. We give you thanks for the miraculous variety of your creation. We pray for the energy and time and patience and talent to learn more about the world you have made, and for the humility always to recognise how little we know. Amen.

Cosmic Prayer,
HOWARD GEORGI (b.1947)
Professor of Physics,
Harvard University

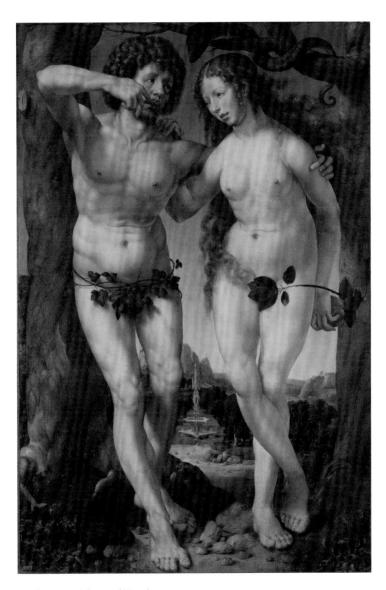

Jan Gossaert, *Adam and Eve*, about 1520

IDOLATRY

Idolatry is the curse of religion, substituting what can be manipulated for what is real but no longer credible or is simply too painful and difficult. G. K. Chesterton observed 'When people stop believing in God they don't believe in nothing, they believe in anything.'

In the formation of the people of Israel, God sets before them a choice of life and death. God's commandments are life-giving ordinances. The exodus from slavery in Egypt is an experience seared into the Jews. Before entering the promised land they wandered for 40 years in the wilderness. They murmured and complained. They lost confidence in Moses and in God. The people felt that Moses had lost his way and that he delayed on Mount Sinai. In Exodus chapter 32, with the priest Aaron's help, they made a golden calf and worshipped it.

Poussin depicts a scene of great drama. In the top left Moses is coming down the mountain carrying the two tablets bearing the covenant with God. There are stormy skies above as he sees the calf and the decadent dancing. The biblical account says Moses burned hot with anger. At the bottom of the mountain Moses broke the tablets, burned the calf, ground it into powder and made the Israelites drink their own foolishness. It is a powerful punishment for their sins.

Keeping the commandments for Jews is the mark of keeping faith with God. The Israelites were not then united by a common system of doctrine or shared statement of belief, a creed, but by the commandments and the twice-daily recitation of the *Shema Yisrael*, the first words in Hebrew of Deuteronomy 6.4.

Hear, O Israel: The Lord is our God, the Lord alone. You shall love the Lord your God with all your heart, with all your soul, and with all your might. Keep these words that I am commanding you today in your heart.

Recite them to your children and talk about them when you are at home and when you are away, when you lie down and when you rise.

Deuteronomy 6: 4–7

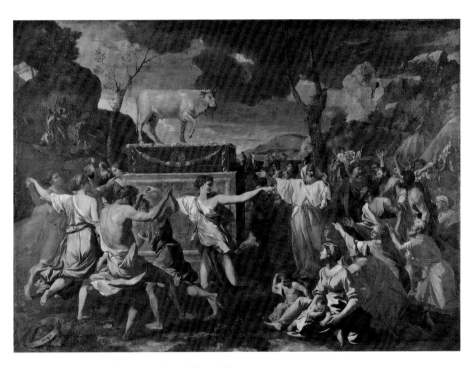

Nicolas Poussin, *The Adoration of the Golden Calf*, 1633–4

RUTH

The Book of Ruth is a beautiful short story set 'in the days when the judges ruled.' Ruth, a Moabite, married an Israelite who was one of two brothers, both of whom died. It was a time of famine and Ruth's mother-in-law, Naomi, decided to return home to Bethlehem. She encouraged the two young widows to return to their own homes. One agreed but Ruth said,

Do not press me to leave you or to turn back from following you! Where you go, I will go; where you lodge, I will lodge; your people shall be my people, and your God my God. Where you die, I will die—there will I be buried. May the LORD do thus and so to me, and more as well, if even death parts me from you!

RUTH 1: 16, 17

In a law remarkably generous to the poor, those who reaped a field were required to leave corn for the destitute to gather. Ruth was allowed to glean in Boaz's field. He protected her because of the faithfulness she had shown to Naomi, though it is also clear she had caught his eye. He married her and they are identified as the ancestors of David, and later of Jesus.

The faithfulness of Ruth, the practical goodness of Naomi, and the generous kindness of Boaz, became an inspiring moral tale for Jews and Christians. It is beautifully realised by von Carolsfeld, who was one of a group of 19th-century German artists interested in painting clearer depictions of biblical narrative. The archaic costumes reflect a longing for a simpler time, which is a recurrent movement in art and religion and is reflected in the simplicity of this Franciscan prayer.

Lord make us instruments
of your peace.
Where there is hatred,
let us sow love;
where there is injury, pardon;
where there is doubt, faith;
where there is despair, hope;
where there is darkness, light;
where there is sadness, joy.
O grant that I may not so much seek
to be consoled as to console,
to be understood as to understand,
to be loved as to love.
For it is in giving that we receive,
it is in pardoning that we are
pardoned,
and it is in dying
that we are born to eternal life.
Amen.

A Franciscan prayer

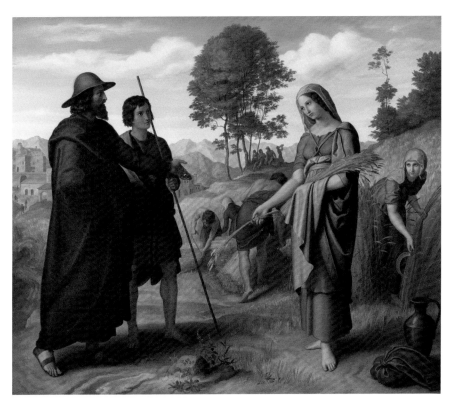

Julius Schnorr von Carolsfeld, *Ruth in Boaz's Field*, 1828

FESTIVAL OF LIGHTS

How to live faithfully in exile has been a repeated problem for Jews, as it is for any religious people. The Book of Daniel purports to come from the time of the Babylonian exile (597–538 BC). King Belshazzar held a shocking sacrilegious feast. He, his lords and concubines drank wine and praised material gods using sacred vessels plundered from the Temple in Jerusalem. A hand appeared frightening the king. The drama of the moment is depicted by Rembrandt with the use of light in darkness, conveying the spiritual intensity of a moment of judgment. Only Daniel, one of the exiles, was able to read the writing on the wall. The days of Belshazzar's reign were numbered because God had weighed him in the scales and found him wanting. Daniel was rewarded for speaking the truth to a powerful person by being clothed in purple, having a gold chain hung around his neck, and being given the rank of third in the kingdom.

Biblical scholars think the Book of Daniel did not reach its final form until about 165 BC. It provided the encouraging example of Daniel to loyal Jews being persecuted by Antiochus Epiphanes, who had also desecrated the Jerusalem Temple. At the re-dedication of the Temple following Judah Maccabee's victory, only a small jug of sanctified oil could be found that remained uncontaminated by paganism, thanks to its seal. Whilst it only contained enough oil to light for one day, it lasted, miraculously, for eight days, by which time more oil had been obtained.

This event is celebrated by the eight-day Festival of Lights, or Hanukkah, meaning 'dedication'. These blessings are said on each night as the family gathers around the Menorah, an eight-branch candle-stand.

Blessed are You, Lord our God, King of the universe, who has sanctified us by His commandments, and has commanded us to kindle the lights of Hanukkah.

Blessed are You, Lord our God, King of the universe, who wrought miracles for our fathers in days of old, at this season.

A third blessing is recited only on the first night.

Blessed are You, Lord our God, King of the universe, who has kept us alive, and has preserved us, and enabled us to reach this time.

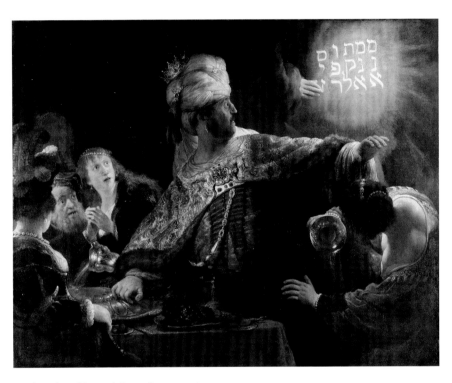

Rembrandt, *Belshazzar's Feast*, about 1636–8

BLINDNESS, SIGHT AND INSIGHT

In the time of the exile in Babylon, it is said that Tobit walked in the ways of truth and righteousness all the days of his life. He performed many acts of charity for his people. After burying the body of a man who had been murdered and thrown into the market place, he slept by the wall of a courtyard where the droppings of sparrows fell into his eyes and blinded him. The now joyless Tobit, feeling the burden of his undeserved suffering, sent his son Tobias on a long journey with a young man to accompany him. The young man was an angel. Whilst Tobias was washing his feet in the River Tigris, a large fish leapt out of the water and was caught. Its gall, heart and liver were used to make medicine to heal the father's blindness when Tobias finally returned home.

This is a story of the love of a son for his father. In this beautiful painting Tobias and the angel are making their way home in haste carrying the fish that will heal poor Tobit's blindness. The dog, a sign of fidelty, was probably painted by a young Leonardo da Vinci, who trained in Verrocchio's workshop.

Fragments of this popular folk tale survived in Aramean and Hebrew and were found among the Dead Sea scrolls in the caves at Qumran in 1952. The full text was otherwise known from the later Greek Bible, the Septuagint. The Book of Tobit is not included in the Jewish canon of scripture. It is included in the Bible by the Eastern Orthodox Church and the Roman Catholic Church. For Church of England Protestants the story is in the Apocrypha.

Having sight and insight are common metaphors in religious life. This prayer by the Bengali poet Rabindranath Tagore conveys energy and joy like that of Tobias and the angel.

When the heart is hard and
 parched up,
come upon me with a shower
 of mercy.
When grace is lost from life,
come with a burst of song.
When tumultuous work raises its
 din on all sides
shutting me out from beyond,
come to me, my Lord of silence
with thy peace and rest.
When my beggarly heart sits
 crouched,
shut up in a corner,
break open the door my King,
and come with the ceremony
 of a king.
When desire blinds the mind with
 delusion and dust,
O thou Holy One, thou wakeful one,
come with thy light and thy
thunder.

RABINDRANATH TAGORE
(1861–1941)

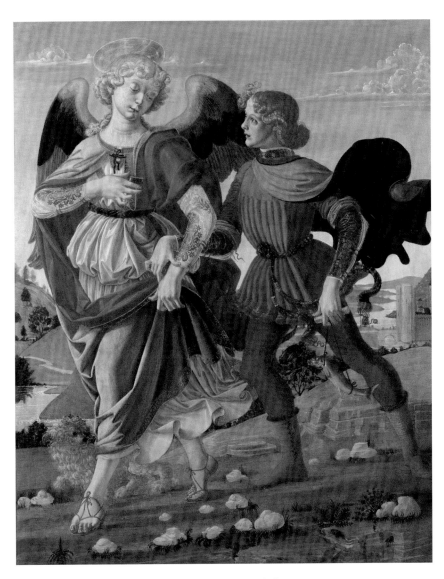

Workshop of Andrea del Verrocchio, *Tobias and the Angel*, about 1470–5

ETERNITY SHUT IN A SPAN

And she gave birth to her firstborn son and wrapped him in bands of cloth, and laid him in a manger, because there was no place for them in the inn.

LUKE 2: 7

The stories of the birth of Jesus are used by Matthew and Luke to give us the eyes to see Christ. The adoration of the shepherds is in Luke's Gospel. The angels proclaim the good news of the birth of Christ first to the shepherds on the hills outside Bethlehem. They light up the night sky, in contrast to the darkness there will be at noon on Good Friday.

The shepherds of Luke's Gospel are people on the edge of society. They would have found it impossible to keep Jewish Law and adhere to the demands of ritual purity up on the hills outside Bethlehem. That the good news is proclaimed by angels first to them establishes a pattern in Luke's Gospel. Christ is known by the poor, the outcast, and those in need of forgiveness. The stable, a Dutch barn, is filled with ordinary working people who have come to worship and wonder. The story of the shepherds links the baby with one of the central images from the Hebrew scriptures applied to Jesus. He is the lamb of God who, like the Passover lamb, will bring God's people to a new freedom.

All babies hold our attention and God's gift of love invites a response. The adoration of this baby by those who have come closest is very striking. Here is light in darkness and 'God in ordinary'.

Welcome, all Wonders in one sight!
Eternity shut in a span.
Summer to winter, day in night,
Heaven in earth, and God in man.
Great little One! Whose all-
 embracing birth
Lifts earth to heaven, stoops
 heaven to earth.

RICHARD CRASHAW (1613–1649)

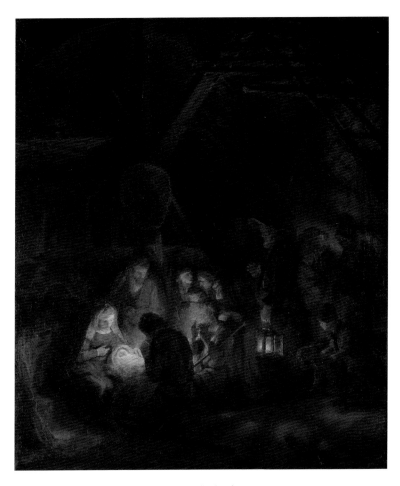

Pupil of Rembrandt, *The Adoration of the Shepherds*, 1646

GIFTS

In the Gospel of Matthew's account of the birth of Jesus there are no shepherds but Magi journey from the East, probably from Persia (modern-day Iran). Magi were more mysterious and magical than the popular translation 'wise men' implies. It was not until Tertullian, an early Christian author, in the 2nd century that anyone thought of them as kings and no one named them as Caspar, Melchior and Balthazar until the 9th century, when these kings came to represent the three parts of the known world: Europe, Africa and Asia. The kings of the earth came to worship the infant king of all. Not until the 7th century did the English monk and historian Bede see the symbolism of their gifts as telling us who Christ is: gold for a king, frankincense for God and myrrh to embalm him when he died.

Gossaert's sumptuous altarpiece shows the kings adoring the infant king in the ruins of the old dispensation. Even though the birth of the Messiah was prophesied in the scriptures, it is not exactly as expected so it needs explaining to those who see but do not understand. The sacrifice of Isaac – a father willing to sacrifice his son out of obedience and love – is carved in a freeze high above the Virgin. Not surprisingly, Joseph looks anxiously to heaven. From above, the angels herald the Christ child and a new dawn.

This painting almost feels three-dimensional. The corridor behind Christ goes both deep and high to heaven. A dove, just below the top arch, and the star above it, present Jesus within the Holy Trinity of God the Father, Son and Holy Spirit.

Behind the Virgin there is a donkey, this side of a half-open narrow gate, with a city beyond. The donkey, with its head down, shows the cross on its back, waiting to carry Christ into the city and on to the Passion at the heart of the Gospel. This painting is a brilliant example of how the whole Gospel can be presented in a single scene.

What can I give him, poor as I am?
If I were a shepherd, I would bring
 a lamb;
If I were a Wise Man, I would do
 my part;
Yet what I can I give him: give
 my heart.

CHRISTINA ROSSETTI (1830–1894)

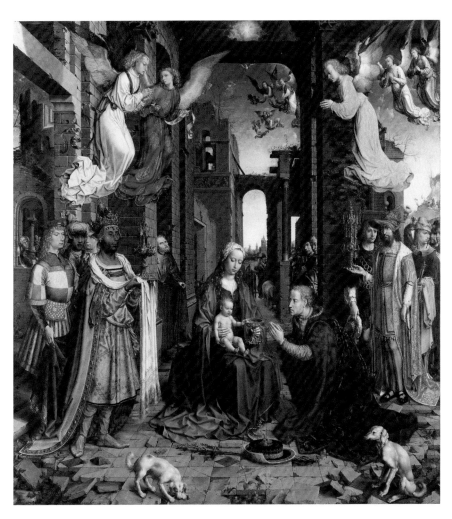

Jan Gossaert, *The Adoration of the Kings*, 1510–15

BAPTISM

In those days Jesus came from Nazareth of Galilee and was baptised by John in the Jordan. And just as he was coming up out of the water, he saw the heavens torn apart and the Spirit descending like a dove on him. And a voice came from heaven, 'You are my Son, the Beloved; with you I am well pleased.'

MARK 1: 9–11

Here is one of the greatest paintings in the Gallery. The baptism of Jesus by John the Baptist is an occasion when the nature of Christ is made known. The central figure of Jesus is an arresting point of stillness. Dressed as he will be on the day he dies, a decision is being made in which Christ is accepting his vocation and his future. The three figures to the left look anxious whilst that on the right has decided to follow him and be baptised. The central vertical line of the painting, from the top of the arch through the dove and Christ, directly links the persons of the one God, Father, Son and Holy Spirit. Jesus, who stands on the earth, is fully human and fully divine.

Through our own baptism Christians are joined with Christ in such a way as to be born again into Christ's resurrection. In the early Church baptisms took place on Easter morning when those who had received instruction throughout Lent were brought up out of the water as if out of the grave to new life.

This prayer blessing the water of baptism is rich in biblical symbolism.

We thank you, almighty God, for the gift of water to sustain, refresh and cleanse all life. Over water the Holy Spirit moved in the beginning of creation. Through water you led the children of Israel from slavery in Egypt to freedom in the Promised Land. In water your Son Jesus received the baptism of John and was anointed by the Holy Spirit as the Messiah, the Christ, to lead us from the death of sin to newness of life.

We thank you, Father, for the water of baptism. In it we are buried with Christ in his death. By it we share in his resurrection. Through it we are reborn by the Holy Spirit. Therefore, in joyful obedience to your Son, we baptise into his fellowship those who come to him in faith.

Now sanctify this water that, by the power of your Holy Spirit, they may be cleansed from sin and born again. Renewed in your image, may they walk by the light of faith and continue for ever in the risen life of Jesus Christ our Lord; to whom with you and the Holy Spirit be all honour and glory, now and for ever. Amen.

Blessing the Water of Baptism,
Common Worship

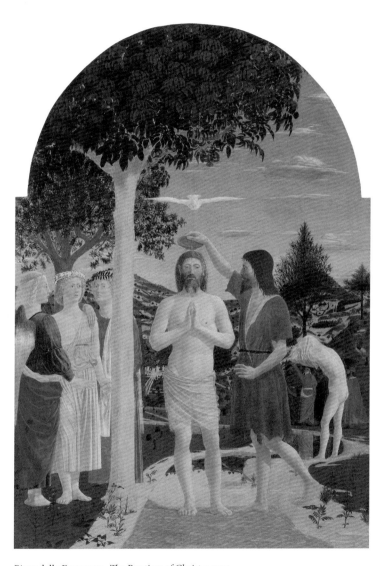

Piero della Francesca, *The Baptism of Christ*, 1450s

MADE IN GOD'S IMAGE

The religious leaders tried to trap Jesus with a political question:

'Teacher, we know that you are sincere, and teach the way of God in accordance with truth, and show deference to no one; for you do not regard people with partiality. Tell us, then, what you think. Is it lawful to pay taxes to the emperor, or not?' But Jesus, aware of their malice, said, 'Why are you putting me to the test, you hypocrites? Show me the coin used for the tax.' And they brought him a denarius. Then he said to them, 'Whose head is this, and whose title?' They answered, 'The emperor's.' Then he said to them, 'Give therefore to the emperor the things that are the emperor's, and to God the things that are God's.'

MATTHEW 22: 15–22

The Venetian painter Titian, sought after by important patrons such as Philip II of Spain, was famous for his powerful depictions of biblical and classical scenes. This painting and Gospel story raises questions about who we are and to whom we belong. What is our true nature? Both are also about issues of religious and secular power.

Titian shows Jesus looking clearly and confidently into the eyes of the person seeking to trap him. Yet in terms of its teaching, this is one of the most enigmatic encounters in the Gospels. Whatever it says about God and Caesar, paying taxes, and the Christian engagement with political life and power, a Jew at the time of Jesus would have heard an unspoken second question: 'And you, whose image are you made in?' We are called to live as people made in God's image.

Jesus taught us to be honest before God and to pray for what we want. This prayer acknowledges our need for God's mercy and voices our longing to be the people God would have us be.

I am two men;
and one is longing to serve thee
 utterly, and one is afraid.
O Lord have compassion upon me.

I am two men;
and one will labour to the end,
 and one is already weary.
O Lord have compassion upon me.

I am two men;
and one knows the suffering
 of the world, and one knows
 only their own.
O Lord have compassion upon me.

And may the Spirit of our Lord
 Jesus Christ
Fill my heart and the hearts of all
 men everywhere.

AUSTEN WILLIAMS (1912–2001)
Vicar of St Martin-in-the-Fields
(1956–1984)

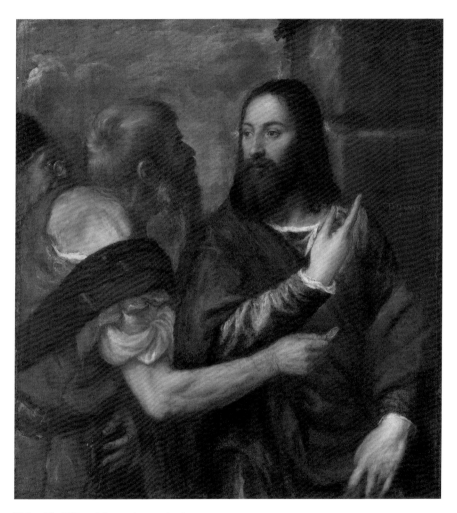

Titian, *The Tribute Money*, about 1560–8

FORGIVENESS

The story about the woman taken in adultery is only told in John's Gospel (John 8: 1–11) and there is considerable doubt that it was in the earliest manuscripts. Nearly all biblical scholars think it is a later addition to the rest of the text. Yet it has become one of the best-known and most-loved stories for probably the same reasons it was added to the Gospel. It is kind and compassionate about what it is to be human and summarises Jesus' teaching about forgiveness with enormous sympathy for the woman. The man with whom she was caught is not mentioned.

We have the immense satisfaction of seeing Jesus put the morally self-righteous in their place. The onlooker hears Christ say, 'Let anyone among you who is without sin be the first to throw a stone at her' to which John adds, 'They went away one by one, beginning with the elders'. In Rembrandt's picture the authority of Jesus is shown by the lighting and by him standing taller than the scribes and Pharisees.

When Jesus was left alone with the woman he asked her, 'Woman, where are they? Has no one condemned you?' She said, 'No one sir.' And Jesus said, 'Neither do I condemn you. Go your way, and from now on do not sin again.'

Rembrandt's painting is great for much the same reasons that this story is one of the most memorable in the Gospels. Here is a very human drama in which the scale of the setting, on the steps going into the Temple, emphasises the scale of the woman's nightmare. The authority of Christ is highlighted by his stature, by the light, which also bathes the woman, and by the stillness at the centre of the group in which she is being accused by the man in black.

The Church of England's attitude to individuals making their confession to a priest is summarised: All may, some should, none must. In liturgy a General Confession is said by all.

Almighty God, our heavenly Father, we have sinned against you and against our neighbour in thought and word and deed, through negligence, through weakness, through our own deliberate fault. We are truly sorry and repent of all our sins. For the sake of your Son Jesus Christ, who died for us, forgive us all that is past and grant that we may serve you in newness of life to the glory of your name. Amen.

To which the Priest responds:

The almighty and merciful Lord grant you pardon and forgiveness for all your sins, time for amendment of life, and the grace and strength of the Holy Spirit. Amen.

Confession and Absolution, *Common Worship*

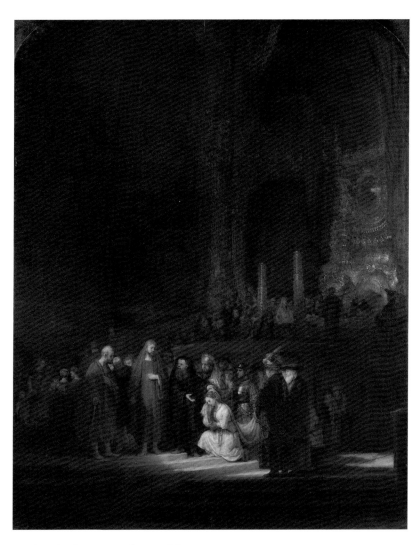

Rembrandt, *The Woman taken in Adultery*, 1644

WHO IS MY NEIGHBOUR?

A lawyer asked Jesus what he must do to have eternal life. Jesus asked him what is written in the law and he replied with the well-known summary that we should love God and love our neighbour as ourselves. Jesus said he was right, 'Do this and you will live.' The lawyer, wanting to justify himself (that's a big mistake for anyone with Jesus), asked, 'And who is my neighbour?' (Luke 10: 25–30).

To answer the lawyer Jesus told the story of the good Samaritan, one of the best-known stories in the Gospels. A man was going down from Jerusalem to Jericho when he was beaten by robbers and left half dead. Two men, a priest and a Levite, were going to Jerusalem. They saw what appeared to be a dead man and had they touched a corpse, they would not have been able to perform their religious duties in the Temple. So for good religious reasons they passed by on the other side. A Samaritan, whom Jews despised, saw the man and was moved to pity. He bandaged him, poured wine and oil on his wounds, put him on his animal and paid for him to stay at an inn. In Bassano's picture the Samaritan literally takes the weight of responsibility for the beaten man.

'Which of these was neighbour to the man who fell into the hands of the robbers?', asked Jesus. 'The one who showed mercy', replied the lawyer, unable even to say the name 'Samaritan', so much were they despised. Our neighbour is anyone in need, not just people like us, and it is scandalous that the despised Samaritan, an outsider, showed good religious people the meaning of the law. Go and do likewise.

Make us O Lord remember that it is Christianity to do good always, even to those who do evil to us, to love our neighbour as ourselves, and to do to all men as we would have them do to us; to be gentle, merciful and forgiving, and to keep those qualities quiet in our own hearts and never make a boast of them; but always to show that we love thee by humbly trying to do the right in everything; that thus remembering the life and lessons of our Lord Jesus Christ and try to act up to them, we may confidently hope that thou wilt forgive us our sins and mistakes and enable us to live and to die in peace through Jesus Christ our Lord. Amen.

'General Prayer for Charity'
CHARLES DICKENS (1812–1870)

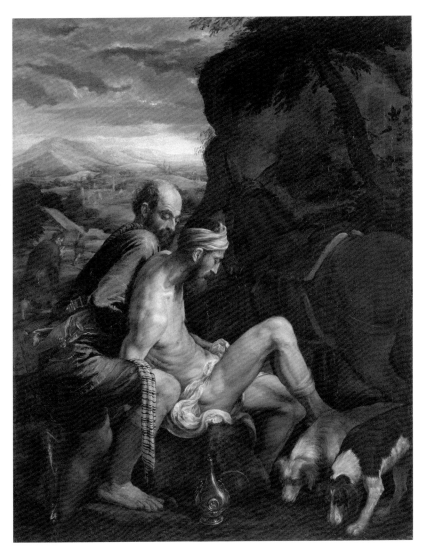

Jacopo Bassano, *The Good Samaritan*, about 1562–3

WORK AND PRAYER

Martha welcomed Jesus into her home. She had a sister named Mary, who sat at the Lord's feet and listened to what he was saying. But Martha was distracted by her many tasks; so she came to him and asked, 'Lord, do you not care that my sister has left me to do all the work by myself? Tell her then to help me.' But the Lord answered her, 'Martha, Martha, you are worried and distracted by many things; Mary has chosen the better part, which will not be taken away from her.'

<div style="text-align: right">LUKE 10: 39–42</div>

In Velásquez's painting an unhappy servant girl is having the story of Mary and Martha told to her so that she will do her work in the right spirit. Her resentment echoes that of Martha at being left by her sister, Mary, to do all the work associated with having a guest. Mary sat at the Lord's feet in the way of a (male) disciple with a Rabbi. Poor Martha was left in the kitchen doing traditional 'women's work' but Jesus says that Mary has chosen the better part, in effect he is affirming her being a disciple who can study, learn and pray.

The story of Martha and Mary is often used to contrast work and prayer but what Jesus actually comments on is that Martha is distracted by her many tasks. In the Benedictine tradition monks are taught, 'To work is to pray and to pray is to work.' John Wesley said, 'Pray as if everything depended on God. Work as if everything depended on you.'

In order to become an Anglican priest, George Herbert gave up a promising career at Cambridge University which might have led to prestigious jobs in politics or finance. In response to the criticism of his friends he wrote a poem which is now a well-known hymn in which the most menial task done in the right spirit can be the highest prize. In this painting the beauty of the still life on the table serves to highlight the beauty of creation.

Teach me, my God and King,
In all things thee to see,
And what I do in any thing,
To do it as for thee:

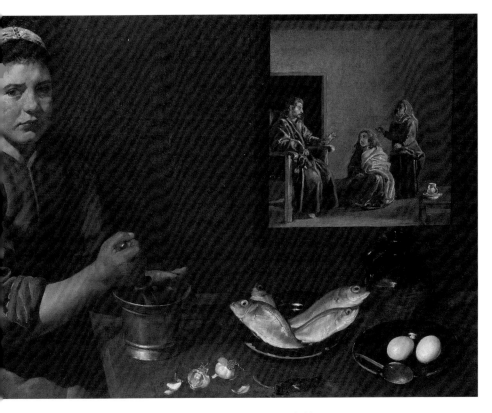

Diego Velázquez, *Christ in the House of Martha and Mary*, probably 1618

A servant with this clause
Makes drudgerie divine:
Who sweeps a room, as for thy laws,
Makes that and th' action fine.

This is the famous stone
That turneth all to gold:
For that which God doth touch and own
Cannot for lesse be told.

The Elixir,
GEORGE HERBERT
(1593–1633), from
The Temple (1633)

LAZARUS, COME OUT!

The story of the raising of Lazarus is told in John's Gospel, chapter 11. Jesus came to the home of his friends, Mary, Martha and Lazarus in Bethany, where Lazarus was ill, but arrived too late. Lazarus was dead and buried. When Lazarus' tomb stone was taken away there was a stench. Jesus cried with a loud voice, 'Lazarus, come out!'

Sebastiano del Piombo's huge painting *The Raising of Lazarus* was an altarpiece commissioned by a new but absentee Archbishop in Rome for the cathedral in Narbonne, France, where there were relics of Lazarus. It is a mission statement for the cathedral: Jesus said to Martha, 'I am the resurrection and the life. Those who believe in me, even though they die, will live, and everyone who lives and believes in me will never die. Do you believe this?'

Historically, faith in what happens after this life has been one of the ways in which Christianity has commended itself to the world. In the 8th-century, the monk the Venerable Bede reports that King Edwin of Northumbria held a council about accepting the faith of Christ. One of the king's chief men said:

Your majesty, when we compare the present life of man on earth with that time of which we have no knowledge, it seems to me like the swift flight of a single sparrow through the banqueting hall where you are sitting at dinner on a winter's day with your thanes and counsellors. In the midst there is a comforting fire to warm the hall; outside, the storms of winter rain or snow are raging. This sparrow flies swiftly in through one door of the hall, and out through another. While he is inside, he is safe from the winter storms; but after a few moments of comfort he vanishes from sight into the wintry world from which he came. Even so, man appears on earth for a little while; but of what went before this life or of what follows, we know nothing. Therefore, if this new teaching has brought any more certain knowledge, it seems only right that we should follow it.

Christ is the morning star
Who when the night is past
Brings to his saints
the promise of the light of life
and opens everlasting day.

BEDE (672–735)

The Venerable Bede
(672–735)
*A History of the English
Church and People,*
Book II, chapter 13
Translation by
Leo Sherley-Price,
revised by R. E. Latham

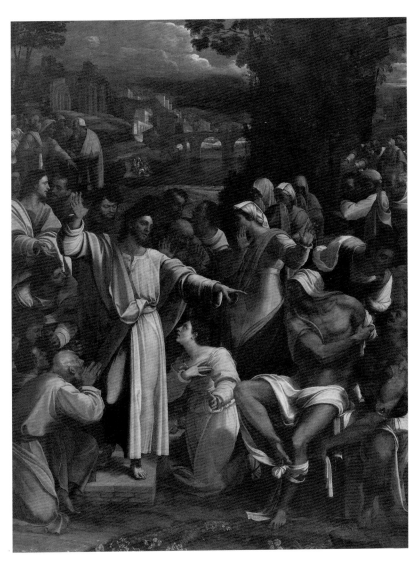

Sebastiano del Piombo, *The Raising of Lazarus*, about 1517–19

SERVICE

During supper Jesus … got up from the table, took off his outer robe, and tied a towel around himself. Then he poured water into a basin and began to wash the disciples' feet and to wipe them with the towel that was tied around him. He came to Simon Peter, who said to him, 'Lord, are you going to wash my feet?' Jesus answered, 'You do not know now what I am doing, but later you will understand.' Peter said to him, 'You will never wash my feet.' Jesus answered, 'Unless I wash you, you have no share with me.' Simon Peter said to him, 'Lord, not my feet only but also my hands and my head!'

<div align="right">JOHN 13: 3–9</div>

John's Gospel gives us the grand picture of the glory of God in life, death and the resurrection of Jesus Christ. The creative Word of God, which was in the beginning, is identified with the particular being of Jesus of Nazareth. God is known in the light of the world, water of life, bread of heaven, true vine; each of which, in Christ, is eternal. Love is feeding the hungry with the bread of life, healing the sick, and the humble service of a master washing his disciples' feet.

The unusual perspective in Tintoretto's painting is due to the fact that it was made for a narrow chapel, and is meant to be viewed from the left looking towards the altar. The light of Christ in the darkness emphasises his divinity in the humility of loving service. Nearest the altar Judas, who is drying his feet, which have already been washed by Jesus, is separated from the other disciples. This is a reference to Psalm 41: 9:

Even my bosom friend in whom I trusted, who ate of my bread, has lifted his heel against me.

Judas has lifted his heel and turned his back on Jesus and on us. He will go out cloaked in darkness to betray Jesus. The painting presents us with a choice.

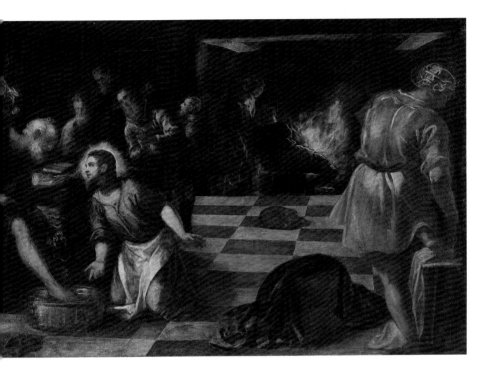

Jacopo Tintoretto, *Christ washing the Feet of the Disciples*, about 1575–80

Jesus Lord and Master, who
served your disciples in washing
their feet: serve us often, serve us
daily, in washing our motives, our
ambitions, our actions; that we
may share with you in your
mission to the world and serve
others gladly for your sake; to
whom be glory for ever. Amen.

MICHAEL RAMSEY
(1904–1988)
Archbishop of Canterbury
(1961–1974)

THE LIGHT SHINES IN THE DARKNESS

The high priest stood up and said, 'Have you no answer? What is it that they testify against you?' But Jesus was silent. Then the high priest said to him, 'I put you under oath before the living God, tell us if you are the Messiah, the Son of God.' Jesus said to him, 'You have said so. But I tell you, from now on you will see the Son of Man seated at the right hand of Power and coming on the clouds of heaven.' Then the high priest tore his clothes and said, 'He has blasphemed! Why do we still need witnesses? You have now heard his blasphemy. What is your verdict?' They answered, 'He deserves death.'

MATTHEW 26: 62–66

Goodness is stronger than evil;
Love is stronger than hate;
Light is stronger than darkness;
Life is stronger than death;
Victory is ours through Him who loves us.

DESMOND TUTU (b.1931)
Archbishop of Cape Town (1986–96)

That the trial of Jesus happened in the night is used to great effect in this painting. Gerrit van Honthorst used light and dark to reveal the truth. Christ stands accused by the High Priest. He is judged by an open book and by the light of a candle which will burn out. Christ stands serene and passive. As in John's Gospel, he is the light of the world.

In this conflict with conventional religion, Jesus' silence ought to give all religious people pause for thought about our confident judgements of right and wrong. It is so easy to misuse scripture, as is shown in this picture in which confident judgement is made by an open book. Saint John's Gospel voices the hope that in Christ, 'the light shines in the darkness and the darkness did not overcome it' (John 1: 5).

In the north-east corner of Trafalgar Square St Martin-in-the-Fields' neighbours are the National Gallery and South Africa House. At the height of apartheid in South Africa, a political system of racism which claimed religious and biblical support, Archbishop Desmond Tutu knew that the victory was already won by those who opposed it because goodness is stronger than evil. This prayer is one of the great prayers of an oppressed people. In Christ the light has already won the battle with darkness.

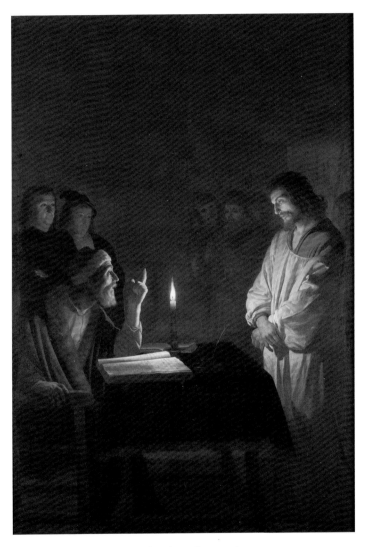

Gerrit van Honthorst, *Christ before the High Priest*, about 1617

A MAN OF SORROWS

This brutal picture depicts the mocking of Christ and his crowning with thorns. Those tormenting Christ are presented as grotesque savage beasts. The man in the top right-hand corner even wears a spiked dog collar. They are unbelievers, the man in the bottom left has a star and Islamic crescent on his headdress. These crude caricatures are deeply troubling to modern eyes. They contrast sharply with the gentle Christ who looks out at us, establishing a different relationship, his crown of thorns set like a halo.

Jews at the time of Jesus would have been astonished that passages in the prophet Isaiah about the Suffering Servant could be applied to the Messiah, for whom they longed and waited to set them free. Matthew used them in his Gospel to show that Jesus shared our human nature fully and that his suffering was according to the prophets. For some of us familiarity with this bold use of scripture owes a great deal to George Frideric Handel (1685–1759) whose *Messiah* was first performed in 1742. In its central section one of its finest arias and chorus uses verses from Isaiah chapter 53: 3–5.

> He was despised and rejected of men; a man of sorrows and acquainted with grief. He gave His back to the smiters, and His cheeks to them that plucked off the hair: He hid not His face from shame and spitting.

> Surely He hath borne our griefs, and carried our sorrows! He was wounded for our transgressions; He was bruised for our iniquities; the chastisement of our peace was upon Him. And with His stripes we are healed.

As Chancellor of the Diocese of Canterbury and then as Bishop of Chichester, Richard de Wych was in conflict with King Henry III and knew what it was to suffer and be insulted. In an extraordinarily intimate prayer Saint Richard recognises that Christ carries the burdens for us and strengthens our discipleship.

Thanks be to thee Lord
Jesus Christ for all the benefits
which thou hast given me,
for all the pains and insults which
thou hast borne for me,
O most merciful redeemer,
friend and brother,
may I see thee more clearly,
love thee more dearly,
and follow thee more nearly.
Amen.

SAINT RICHARD OF CHICHESTER
(1197–1253)

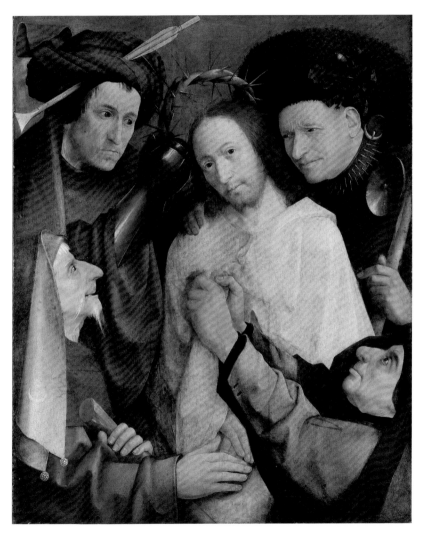

Hieronymus Bosch, *Christ Mocked (The Crowning with Thorns)*, about 1490–1500

CRUCIFIXION

This painting of the crucifixion originally formed part of the lower section of an altarpiece. The altar in churches is where the sacrifice of Christ is remembered using bread and wine, where the bread, which is the body of Christ, is raised up to feed God's people now and bring us to share in the resurrection.

The ways in which this is presented in the four Gospels differ markedly. In John's Gospel Jesus Christ shows the glory of God as he gives himself to the will of God. There is no agony in the Garden of Gethsemane, he is 'raised up' on the cross and his body is not broken. In the other three Gospels he suffers as we suffer and his body is bruised and broken.

How Christ shares human suffering was one of the major theological debates of the 20th century, a century in which more people were killed in warfare and genocide than in all the previous centuries combined. W. H. Vanstone was a Church of England parish priest in Sheffield. He wrote this poem and a highly influential book of the same name, out of his experience of parish ministry.

Morning glory, starlit sky,
Soaring music, scholars' truth,
Flight of swallows, autumn leaves,
Memory's treasure, grace of youth:

Open are the gifts of God,
Gifts of love to mind and sense;
Hidden is love's agony,
Love's endeavour, love's expense.

Love that gives, gives ever more,
Gives with zeal, with eager hands,
Spares not, keeps not, all outpours,
Ventures all, its all expends.

Drained is love in making full,
Bound in setting others free,
Poor in making many rich,
Weak in giving power to be.

Therefore he who shows us God
Helpless hangs upon the tree;
And the nails and crown of thorns
Tell of what God's love must be.

Here is God: no monarch he,
Throned in easy state to reign;
Here is God whose arms of love
Aching, spent, the world sustain.

Love's Endeavour,
W. H. VANSTONE (1923–1999)

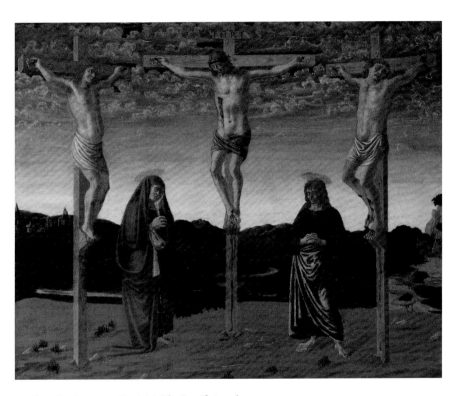

Attributed to Francesco Botticini, *The Crucifixion*, about 1471

THE ENTOMBMENT

They took the body of Jesus and wrapped it with spices in linen cloth, according to the burial custom of the Jews. Now there was a garden in that place where he was crucified, and in the garden there was a new tomb in which no one had ever been laid. And so, because it was the Jewish day of Preparation, and the tomb was nearby, they laid Jesus there.

JOHN 19: 40–42

In this painting the body of Christ is being carried to his tomb. It is thought that the picture was created for an unfinished altarpiece, which would explain this rare frontal representation, showing Christ being raised up and presented to those who would be about to receive communion in church, the body of Christ in the sacramental form of bread and wine. Christ's body is unblemished and shows no wounds from the cross.

There is doubt over the identity of the various figures represented because they are incomplete and are not all easy to identify. They are a beautiful mix of contemplation and reverent activity. Saint John the Evangelist is usually shown in red with long hair, and may be the figure on the left carrying Christ. The figure kneeling on the left is probably Mary Magdalene and the woman to the right is probably Mary, the wife of Clopas. The incomplete outline in the bottom right is the Virgin. The others are probably Nicodemus, who first came to Jesus by night, and Joseph of Arimathaea, who gave up his tomb for Jesus and had been a secret disciple. The death of Christ has brought them into the light and they no longer act in secret.

Anima Christi (Soul of Christ) is a 14th-century prayer with vivid imagery of the body and blood of Jesus and the power of Christ's identification with us. It was possibly written by Pope John XXII and was placed by Saint Ignatius Loyola (1491–1556) at the front of his *Spiritual Exercises*.

Soul of Christ, sanctify me,
body of Christ, save me,
blood of Christ, inebriate me,
water from the side
of Christ, wash me.
Passion of Christ,
strengthen me.
O good Jesus, hear me:
hide me within your
wounds and never let me
be separated from you.
From the wicked enemy
defend me, In the hour
of my death, call me
And bid me come to you,
So that with your saints
I may praise you,
For ever and ever. Amen.

ANON, *Anima Christi*,
14th century

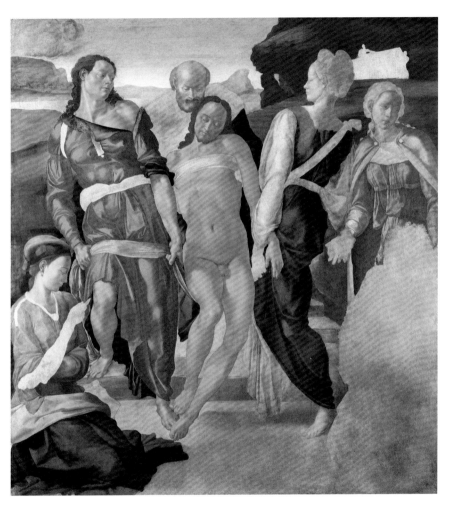

Michelangelo, *The Entombment*, about 1500–1

DO NOT TOUCH ME

The stories of Jesus in the New Testament are all told from the perspective of his resurrection and Easter morning. They push the boundaries of our experience and understanding, as they did for the first Christians. Titian's painting is of John's Gospel but set in his own day. Mary Magdalene is a typical Venetian beauty in contemporary dress. She encounters the risen Christ and mistakes him for the gardener. She is told not to touch him because he has not yet ascended to the Father in heaven, in contrast to the experience of all Christians when they receive the body of Christ in bread and wine at the Eucharist, the central act of worship in church.

But Mary stood weeping outside the tomb. As she wept, she bent over to look into the tomb; and she saw two angels in white, sitting where the body of Jesus had been lying, one at the head and the other at the feet. They said to her, 'Woman, why are you weeping?' She said to them, 'They have taken away my Lord, and I do not know where they have laid him.' When she had said this, she turned around and saw Jesus standing there, but she did not know that it was Jesus. Jesus said to her, 'Woman, why are you weeping? Whom are you looking for?' Supposing him to be the gardener, she said to him, 'Sir, if you have carried him away, tell me where you have laid him, and I will take him away.' Jesus said to her, 'Mary!' She turned and said to him in Hebrew, 'Rabbouni!' (which means Teacher). Jesus said to her, 'Do not hold on to me, because I have not yet ascended to the Father. But go to my brothers and say to them, 'I am ascending to my Father and your Father, to my God and your God.'

JOHN 20: 11–17

Now the green blade riseth from
 the buried grain,
Wheat that in dark earth many days
 has lain;
Love lives again, that with the dead
 has been:
Love is come again,
Like wheat that springeth green.

J. M. C. CRUM (1872–1958)

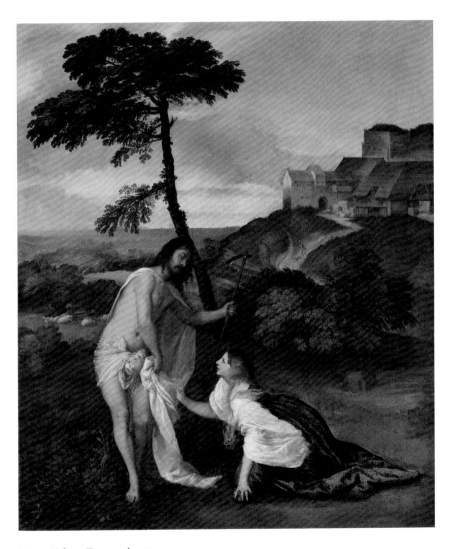

Titian, *Noli me Tangere*, about 1514

THE SUPPER AT EMMAUS

On that first Easter day, two disciples walked to Emmaus, a village about seven miles from Jerusalem. While they walked they talked about the events of the last few days. Jesus joined them, but they did not recognise him. As they journeyed together he interpreted what had happened through the scriptures, beginning with Moses and the prophets.

As they came near the village to which they were going, he walked ahead as if he were going on. But they urged him strongly, saying, 'Stay with us, because it is almost evening and the day is now nearly over.' So he went in to stay with them. When he was at the table with them, he took bread, blessed and broke it, and gave it to them. Then their eyes were opened, and they recognised him; and he vanished from their sight.

LUKE 24: 28–31

Caravaggio has depicted the moment of revelation. Jesus does not have the traditional beard so is not recognised until the familiar blessing of the bread. To the disciples, though not the waiter, it is startling. The dish of ripe fruit is about to tip off the table towards us. The disciple on the right is wearing a scallop shell, the badge of a pilgrim, someone 'on the way'. The other's elbow pushes through a hole in his jacket and the painting's canvas as it pierces our space. The gap on this side of the table invites us to join the meal in which Christ meets us.

The stories of the resurrection in the Gospels are transitory moments significant enough to change lives for ever.

Father of all, we give you thanks and praise, that when we were still far off you met us in your son and brought us home. Dying and living he declared your love, gave us grace, and opened the gate of glory. May we who share Christ's body live his risen life; we who drink his cup bring life to others; we whom the spirit lights give light to the world. Keep us firm in the hope you have set before us, so we and all your children shall be free, and the whole earth live to praise your name; through Jesus Christ our Lord. Amen

Prayer after Communion, *Common Worship*

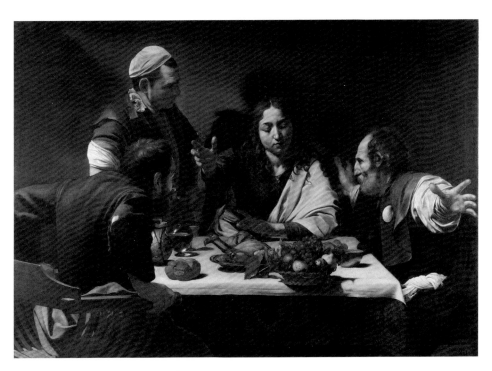

Michelangelo Merisi da Caravaggio, *The Supper at Emmaus*, 1601

We praise thee, O God:
we acknowledge thee to be the Lord.
All the earth doth worship thee:
the Father everlasting.
To thee all Angels cry aloud:
the Heavens, and all the Powers therein.
To thee Cherubin and Seraphin:
continually do cry,
Holy, Holy, Holy:
Lord God of Sabaoth;
Heaven and earth are full of the Majesty:
of thy glory.

Te Deum Laudamus

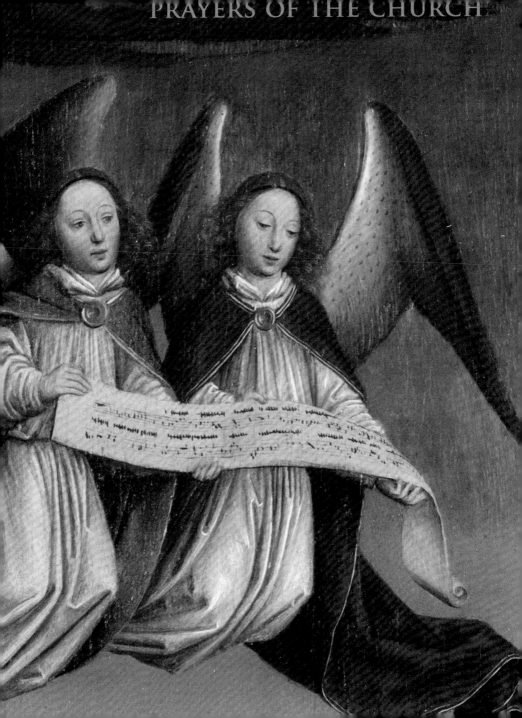

HOLY COMMUNION

Holy communion is the Christian Church's central act of worship. Its different names emphasise aspects of its character: Communion with God and one another through Jesus Christ; the Eucharist, a thanksgiving; and the Mass from which God's people are sent out, dismissed, to join in the mission of God in the world. The earliest account of communion is in Saint Paul's First Letter to the Corinthians.

This magisterial commentary is from the Anglican Benedictine monk Dom Gregory Dix.

> Was ever another command so obeyed? For century after century, spreading slowly to every continent and country and among every race on earth, this action has been done, in every conceivable human circumstance, for every conceivable human need from infancy and before it to extreme old age and after it, from the pinnacles of earthly greatness to the refuge of fugitives in the caves and dens of the earth. People have found no better thing than this to do for kings at their crowning and for criminals going to the scaffold; for armies in triumph or for a bride and bridegroom in a little country church; for the wisdom of a Parliament or for a sick old woman afraid to die; for a schoolboy sitting an examination or for Columbus setting out to discover America; for the famine of whole provinces or for the soul of a dead lover … while the lions roared in the nearby amphitheatre; on the beach at Dunkirk; while the hiss of scythes in the thick June grass came faintly through the windows of the church … one could fill many pages with the reasons why people have done this, and not tell a hundredth part of them. And best of all, week by week and month by month, on a hundred successive Sundays, faithfully, unfailingly, across all the parishes of Christendom, the pastors have done this just to make the 'plebs sancta dei' – the holy common people of God.
>
> Dom Gregory Dix, *The Shape of the Liturgy*, 1945

For I received from the Lord what I also handed on to you, that the Lord Jesus on the night when he was betrayed took a loaf of bread, and when he had given thanks, he broke it and said, 'This is my body that is for you. Do this in remembrance of me.' In the same way he took the cup also, after supper, saying, 'This cup is the new covenant in my blood. Do this, as often as you drink it, in remembrance of me.'

1 CORINTHIANS 11: 23–25

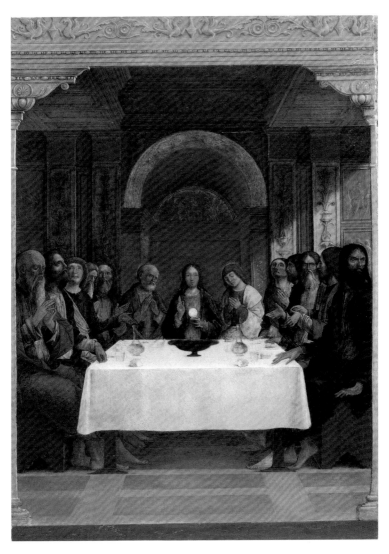

Ercole de' Roberti, *The Institution of the Eucharist*, probably 1490s

MAGNIFICAT

Mary said to the angel, 'How can this be, since I am a virgin?' The angel said to her, 'The Holy Spirit will come upon you, and the power of the Most High will overshadow you; therefore the child to be born will be holy; he will be called Son of God. Then Mary said, 'Here am I, the servant of the Lord; let it be with me according to your word.'

LUKE 1: 34–35, 38

At the Annunciation the angel said to Mary that she would bear God's son. It is an announcement that turns the world upside down: God taking human form through a young girl yet to be married. In response Mary magnifies the Lord. In St Martin's, or any church, at choral evensong Mary's song often sounds ethereal but it engages the spiritual with the powers of this world. God's truth and love come among us. The baby borne by this young woman has been felt a threat by earthly rulers from King Herod onwards.

Far from finding the Annunciation threatening, Crivelli's *Annunciation* joyfully joins the religious and political realms in this altarpiece for the Church of the Annunciation in Ascoli Piceno, Italy. The angel Gabriel has landed in the street next to the city's patron saint, Emidius, who holds a model of the city. The inscription beneath reads LIBERTAS ECCLESIASTICA, the title of the papal edict granting the city limited powers of self-government. This good news arrived on the Feast of the Annunciation, 25 March 1482, so the two announcements are linked. A man on the bridge is reading the message brought by carrier pigeon rather than holy dove. The people go about their business amidst the beautiful architecture of the town as the golden beam of the Spirit of God alights on Mary through a providentially placed hole in the wall of her grand house. The peacock symbolises immortality because its flesh was thought not to decay, and the 'eyes' on its tail represent the 'all-seeing Church'.

My soul doth magnify the Lord:
and my spirit hath rejoiced
in God my Saviour.
For he hath regarded: the lowliness
of his handmaiden.
For behold, from henceforth: all
generations shall call me blessed.
For he that is mighty hath
magnified me: and holy is his Name.
And his mercy is on them
that fear him: throughout
all generations.
He hath shewed strength
with his arm:
he hath scattered the proud
in the imagination of their hearts.
He hath put down the mighty
from their seat:
and hath exalted the humble
and meek.
He hath filled the hungry with
good things:
and the rich he hath sent
empty away.
He remembering his mercy
hath holpen his servant Israel:
as he promised to our forefathers,
Abraham and his seed for ever.

Church of England, *Book of Common Prayer*, 1662
From Luke 1: 46–55

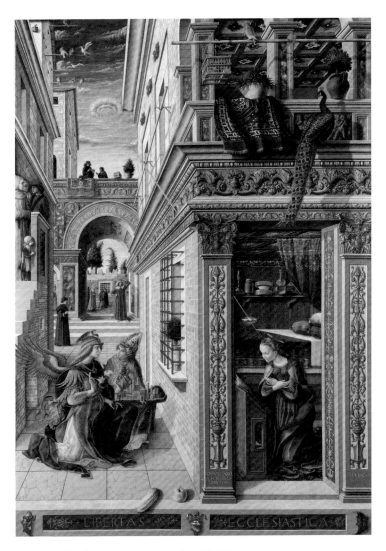

Carlo Crivelli, *The Annunciation, with Saint Emidius*, 1486

ANGELS

Do not neglect to show hospitality to strangers, for by doing that some have entertained angels without knowing it.

<div align="right">HEBREWS 13: 2</div>

Angels are messengers from God. Sometimes they are supernatural, sometimes they take human form. That they figure in everyday language shows the universality of our experience that there is more to life than meets the eye and that some people or events function as the means by which we encounter God.

At the consecration of the new church of St Martin-in-the-Fields on 20 October 1726 the Vicar, the Revd Dr Zachariah Pearce, preached for a great deal longer than is customary now. His text was the story in Genesis chapter 28 of angels ascending and descending on Jacob's ladder connecting earth and heaven. Jacob exclaimed that this place is 'Bethel', the house of God and gate of heaven. Jacob's ladder has recurring significance for St Martin's where there are over 70 angels, many of them in the beautiful plaster ceiling as if peaking through from heaven above to earth below. On a cold night in 1887 the Churchwarden, John McMaster, gave a dejected young match seller a room at his shop in Panton Street behind the National Gallery. The match seller was Francis Thompson, a shy, depressed opium addict and visionary Roman Catholic and poet. One of his best-loved poems is *The Kingdom of God* which is also known as *In No Strange Land*.

O world invisible, we view thee,
O world intangible, we touch thee,
O world unknowable, we know thee,
Inapprehensible, we clutch thee!

Does the fish soar to find the ocean,
The eagle plunge to find the air –
That we ask of the stars in motion
If they have rumour of thee there?

Not where the wheeling systems darken
And our benumbed conceiving soars!
The drift of pinions, would we hearken,
Beats at our own clay-shuttered doors.

The angels keep their ancient places –
Turn but a stone and start a wing!
'Tis ye, 'tis your estrangèd faces,
That miss the many-splendoured thing.

But (when so sad thou canst not sadder
Cry – and upon thy so sore loss
Shall shine the traffic of Jacob's ladder
Pitched betwixt Heaven and Charing
 Cross.

Yea, in the night, my Soul, my daughter,
Cry – clinging to Heaven by the hems;
And lo, Christ walking on the water,
Not of Genesareth, but Thames!

FRANCIS THOMPSON, (1859–1907)

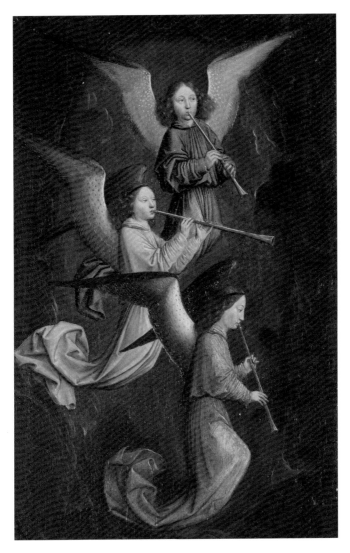

Simon Marmion, *A Choir of Angels*, from left-hand shutter, about 1459

TRANSFIGURATION

Every religion carries within it an account of what it means to be human. The glorious possibility of God in human nature is shown in the accounts in the first three Gospels of the transfiguration of Christ.

Jesus took with him Peter and John and James, and went up on the mountain to pray. And while he was praying, the appearance of his face changed, and his clothes became dazzling white.

LUKE 9: 28–29

John does not tell this story but his whole Gospel shows Christ's glory:

And the Word became flesh and lived among us, and we have seen his glory, the glory of a father's only son, full of grace and truth.

JOHN 1: 14

The radiance of holy people is striking. Duccio uses gold on Christ's garments to show him transfigured and the glory of this is all around. Jesus on a mountain echoes Moses on Mount Sinai whose holiness was also striking when God gave him the Law. The appearance of Elijah and Moses beside Jesus shows the support of the Jewish prophets and Law in identifying Jesus as the Messiah.

The Feast of the Transfiguration is on 6 August. This started as a local and unofficial festival in the Eastern Church, but became widespread before AD 1000. In the West its general observance dates from Pope Callistus III's order of its universal celebration to commemorate the victory over the Turks at Belgrade on 6 August 1456. In modern times there is a connection to the terrible destruction of humanity in the bombing of Hiroshima on 6 August 1945: the disfigurement of our human nature. A nuclear bomb created a mushroom cloud and intense light and heat that incinerated some 20 per cent of the 140,000 people who died.

Let us pray as Christ taught his disciples:

Our Father, who art in heaven,
Hallowed be thy name;
thy kingdom come;
thy will be done;
on earth as it is in heaven.
Give us this day our daily bread.
And forgive us our trespasses,
as we forgive those who
trespass against us.
And lead us not into temptation;
but deliver us from evil.
For thine is the kingdom,
the power and the glory,
For ever and ever. Amen.

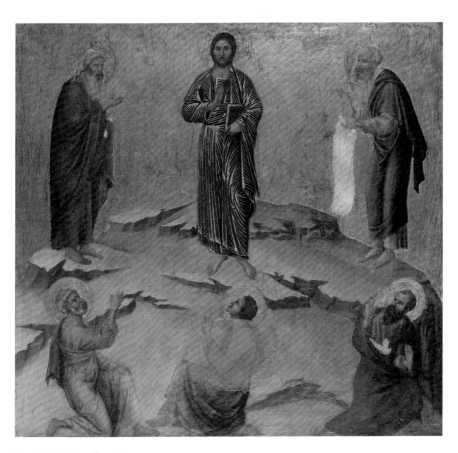

Duccio, *The Transfiguration*, 1311

ROYALTY

This exquisite small portable altarpiece came from Wilton House in Wiltshire. A diptych is a painting on two panels, in this case made of oak and hinged like a book. It was made for the private devotion of Richard II, King of England (1377–1399), near the end of his life. Richard was born on 6 January, the Feast of the Epiphany when Christ was worshipped by the Magi, who became the three kings. Richard is shown kneeling before the Virgin Mary who holds the infant Jesus. Jesus is surrounded by a company of angels and stretches out to bless Richard. Supporting King Richard are Edward the Confessor, who until the Crusades was the patron saint of England, and Saint Edmund: three English kings. John the Baptist was Richard's patron saint. An angel close to the infant Christ and the Virgin holds the flag of Saint George, above which a tiny orb reflects an astonishing miniature map of England. It may be what John of Gaunt is describing in Shakespeare's *Richard II*: 'This royal throne of kings, this scepter'd isle… This precious stone set in the silver sea… This blessed plot, this earth, this realm, this England.' Christ stretches out in blessing.

Shakespeare's Richard II also spoke of his mortality, 'Let's talk of graves, of worms, and epitaphs.'

> For you have but mistook me all this while:
> I live with bread like you, feel want,
> Taste grief, need friends: subjected thus,
> How can you say to me, I am a king?
>
> Act 3, Scene 2

In 1542 King Henry VIII created the parish of St Martin-in-the-Fields out of St Margaret's Westminster, so that plague victims would be taken away from the palace of Whitehall. So St Martin's became known as the Royal Parish Church because of its care of the dead.

If Shakespeare's Richard II reflected upon the humanity of kings, we might also consider the dignity of all humanity.

You are a chosen race, a royal priesthood, a holy nation, God's own people, in order that you might proclaim the mighty acts of him who called you out of darkness into his marvellous light.

1 PETER 2:9

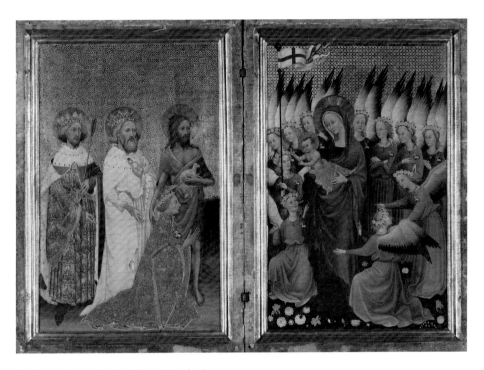

English or French (?), *The Wilton Diptych*, about 1395–9

SAINT MARTIN

Saint Martin (316–397) was a soldier. As a child he longed to become a Christian but he was required to follow his father, who was an officer in the Roman army. In the early 4th century Christians could not be soldiers, less because of the pacifism of the early Church, more because of being unable to swear an oath to the emperor as god. On a cold winter's day, riding out of the city of Amiens in northern France, Martin cut his cloak in half and shared it with a beggar. That night in a dream the beggar returned to him as Christ. It is an act that echoes the words of Jesus in Matthew 25: 41 in which Jesus said, 'Just as you did it to one of the least of these, you did it to me.'

On leaving the army Martin was ordained and lived as a hermit near Poitiers. In 371 he became Bishop of Tours. He was the first person to be made a saint because of the way he lived rather than the way he died, a confessor rather than a martyr. His paradoxical influence is immense in the Christianity of Europe in both its Celtic and Roman forms. He is the patron saint of soldiers and pacifists. His church 'in the fields' in the heart of London, is named after one of the patron saints of France and now sits on the edge of Trafalgar Square, named after Britain's greatest naval victory over the French.

Solimena's painting is a version of another picture in the monastery of San Martino in Naples. It probably came into the possession of St Martin-in-the-Fields soon after the present church was built and depicts the story of its patron saint. The length and luxury of Martin's cloak may be a veiled comment because the monastery of San Martino was known to be immensely wealthy. This painting was lent to the National Gallery for safe-keeping and now the church's building renewal is complete, it has been returned.

O God, our Heavenly Father, give us a vision of our world as your love would make it: a world where the weak are protected and none go hungry or poor; a world where the benefits of civilised life are shared, and everyone can enjoy them; a world where different races, nations and cultures live in tolerance and mutual respect; a world where peace is built with justice, and justice is guided by love; and give us the inspiration and courage to build it, through Jesus Christ our Lord. Amen.

St Martin-in-the-Fields' 'Prayer for the World' GEOFFREY BROWN (b.1930) Vicar of St Martin-in-the-Fields (1985–1995) and JOHN PRIDMORE (b.1936) Assistant Curate (1989–1995)

Francesco Solimena, *Saint Martin sharing his Cloak with the Beggar*, early 1730s

THE RICHEST OF POOR MEN

Saint Francis (1181/2–1226) was the son of an Umbrian cloth merchant. In response to the love of God and to the astonishment of his father, he renounced his father's wealth and a very comfortable life in order to marry 'lady poverty', care for lepers and rebuild Christ's Church. He gathered around him a company of brothers who committed themselves to live according to a set of rules established by Francis, known as The Rule of Saint Francis. Taking these vows of poverty, chastity and obedience they found extraordinary freedom.

> In that love which is God, I entreat all my friars, ministers and subjects, to put away every attachment, all care and solicitude, and serve, honour and adore our Lord and God with a pure heart and mind. This is what he seeks above all else. We should make a dwelling place within ourselves where he can stay, he who is the Lord God Almighty, Father, Son and Holy Spirit.
>
> The Rule of Saint Francis, 1221

Francis felt the closeness of God and saw God in everything. There are wonderful stories of Francis being at one with God's creation. So closely did he identify with Christ's suffering for the world that in his body he took on the stigmata, the wounds of Christ. In death he saw that we are brought home to God.

Be praised, my Lord, through all your creatures, especially through my lord Brother Sun, who brings the day; and you give light through him. And he is beautiful and radiant in all his splendour! Of you, Most High, he bears the likeness.

Be praised, my Lord, through Sister Moon and the stars; in the heavens you have made them bright, precious and beautiful.

Be praised, my Lord, through Brothers Wind and Air, and clouds and storms, and all the weather, through which you give your creatures sustenance.

Be praised, my Lord, through Sister Water; she is very useful, and humble, and precious, and pure.

Be praised, my Lord, through our sister Mother Earth, who feeds us and rules us, and produces various fruits with coloured flowers and herbs.

Be praised, my Lord, through those who forgive for love of you; through those who endure sickness and trial. Happy those who endure in peace, for by you, Most High, they will be crowned.

SAINT FRANCIS OF ASSISI
(1181/2–1226)
From his *Canticle of the Sun*

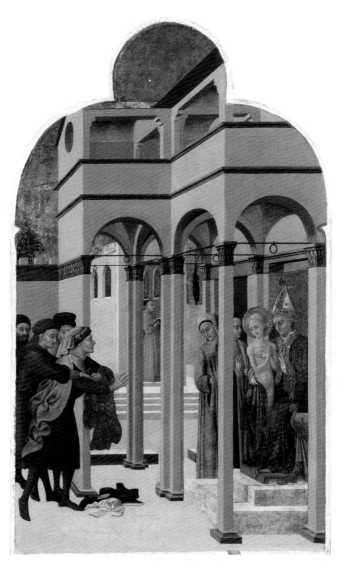

Sassetta, *Saint Francis renounces his Earthly Father*, 1437–44

CHURCH

This medieval parish church in Utrecht is full of light and space, stripped of the decoration of Catholic devotion and whitewashed for Protestant worship. Although Saenredam takes great care with architectural detail, he has exaggerated the impression of the building soaring upwards, emphasising the space and silence which are among the most valuable features of our churches. There is a discipline about the painting as there is about the religious life. The board on the right holds the Ten Commandments given by God to Moses. Beneath them two boys are up to no good. One teaches a dog to stand on its back legs, symbolic of obedience and the capacity to learn, the other is writing graffiti.

Churches are an essential part of our cultural and religious heritage. They are places of memory and carry the history of a community. They are places where people gather to do what Jesus commanded his disciples to do, taking bread and wine in his memory, trying to love one another and seeking forgiveness and grace when things go wrong. Churches mark the rites of passage in our lives – of birth and baptism, the transition to adulthood and mature responsibility, the making of a relationship committed to faithful love, of a thankful life and hopeful death.

Near the door of St Martin-in-the-Fields is a board on which people place their prayers and requests for prayers. In praying for the particular we pray for the universal. The intercessions board may provide us with requests for prayers for people to find jobs, for people who are sick, for someone longing to find love, or in thanksgiving for friends who have died.

God, our Heavenly Father, make, we pray, the door of this church wide enough to welcome all who need human love and fellowship and a Father's care; but narrow enough to shut out all envy, pride and lack of love. Here may the tempted find help, the sorrowing receive comfort, and the penitent be assured of your mercy; and here may all your children renew their strength and go on their way in hope and joy, through Jesus Christ our Lord. Amen.

THOMAS KEN (1637–1711)
Bishop of Bath and Wells
(1685–1690)

Pieter Saenredam, *The Interior of the Buurkerk at Utrecht*, 1644

A RAINBOW COVENANT

John Constable (1776–1837) and Maria Bicknell married at St Martin-in-the-Fields in October 1816. This is one of a number of paintings by Constable of Salisbury Cathedral. It was exhibited at the Royal Academy in 1831 but he continued to work on it during 1833 and 1834. The cathedral is viewed from the north-west, with Long Bridge over the River Avon on the extreme right. The light on the west end of the cathedral and the top of the tallest spire in England is extraordinary. The cathedral rises from the earth through dark storm clouds, as great religious buildings have to do, 'amidst the changes and chances of this troublous life'.

The rainbow was a late addition to this painting. At the end of the story of Noah's flood in the Book of Genesis chapters 6–10, the rainbow is a sign of God's covenant with all creation. This is the broad, generous, inclusive covenant with the occupants of the ark who survived the flood. The cathedral represents that same covenant.

George Herbert was one of the greatest of the metaphysical poets who helped to create the identity of the Church of England. He was also a priest who spent the last three years of his life as Rector of the tiny church at Bemerton, just outside Salisbury, where he was known as Holy Mr Herbert. He was the sort of Rector who once arrived late for a service because he had helped a carter whose load of hay had fallen from his wagon. Herbert's poetry is wonderfully realistic about who we are. He knows himself and human nature 'inside out' and still manages to set the highest of standards.

Of his well-known hymns, probably only 'Let all the world in every corner sing' was written for a congregation to sing. For us it is a joyful response to this painting.

Let all the world in every corner sing,
My God and King!
The heavens are not too high,
His praise may thither fly;
The earth is not too low,
His praises there may grow.
Let all the world in every corner sing,
My God and King!

Let all the world in every corner sing,
My God and King!
The Church with psalms must shout,
No door can keep them out;
But above all the heart
Must bear the longest part.
Let all the world in every corner sing,
My God and King!

GEORGE HERBERT (1593–1633)

John Constable, *Salisbury Cathedral from the Meadows*, 1831

THE TRINITY

Having read the scriptures and prayed in and with the Church, what can we say about God? The commandments include the prohibition of images of God. Similarly, one strand of biblical thought declines to speak of God because to do so would be to limit and diminish God. Even so, in the Bible God has many names and the scriptures witness to a Trinity of Father, Son and Holy Spirit, the three persons and one God depicted in this section of an altarpiece.

The early Church developed creeds, statements of belief, to guard the truth of the Christian faith and unity of the Church. The Catholic, universal, creeds are still recited in Church today. They are the normative agreed texts and are represented figuratively in this painting of God the Father in heaven holding his son Jesus Christ on the cross in the earth, with the dove, the Holy Spirit, hovering between them.

The complexity of experience, thought and language represented by the Trinity is in many ways satisfying as we attempt to talk of God and express the infinite in the finite. Inevitably there is also a rich body of more accessible imagery and language in the popular traditions of the Church. Among the loveliest is this Irish prayer, probably from the 8th century.

I arise today
Through a mighty strength, the
invocation of the Trinity,
Through the belief in the threeness,
Through confession of the oneness
Of the Creator of Creation.

I arise today
Through the strength of heaven:
Light of sun, Radiance of moon,
Splendor of fire, Speed of lightning,
Swiftness of wind, Depth of sea,
Stability of earth, Firmness of rock.

Christ with me, Christ before me,
Christ behind me,
Christ in me, Christ beneath me,
Christ above me,
Christ on my right, Christ on my left,
Christ when I lie down, Christ when
I sit down, Christ when I arise,
Christ in the heart of every man
who thinks of me,
Christ in the mouth of everyone
who speaks of me,
Christ in every eye that sees me,
Christ in every ear that hears me.

I arise today
Through a mighty strength, the
invocation of the Trinity,
Through belief in the threeness,
Through confession of the oneness,
Of the Creator of Creation.

ANON, 8th-century Irish prayer;
translated by Kuno Meyer

Giovanni dal Ponte, *The Trinity*, centre pinnacle, about 1420–4?

Be patterns, be examples
in all countries, places, islands,
nations wherever you come;
that your carriage and life
may preach among all sorts
of people, and to them;
then you will come to walk
cheerfully over the world,
answering that of God in
everyone; whereby in them
you may be a blessing, and
make the witness of God
 in them to bless you.

GEORGE FOX (1624–1691)

72

THE BEAUTY OF HOLINESS

In Zurbarán's exquisite still life a delicate white ceramic cup is filled almost to the brim with water. A pink rose rests on the rim of the plate that the cup rests on and is delicately reflected in it. The wooden shelf and dark background, coupled with the soft light, display life-size objects of great beauty.

The 17th-century Spanish painter Zurbarán used the physical to symbolise the spiritual. The rose in the picture may represent the 'mystic rose' of Paradise and the Virgin Mary. The pure water in the cup is the living water by which, like the Samaritan woman who met Christ at the well in John chapter 4, Christ enlivens us.

This painting is almost sacramental in the way it invites us to find God in the holiness of beauty and the beauty of holiness. It also invites a response in the way we enjoy and use these objects, perhaps pointing to the holiness of offering simple hospitality and welcoming a guest.

There is no rose of such virtue
As is the rose that bare Jesu;
For in this rose contained was
Heaven and earth in little space.

ANON, 15th-century, English Christmas carol

'Tis the gift to be simple,
'tis the gift to be free,
'Tis the gift to come down
where we ought to be,
And when we find ourselves
in the place just right,
'Twill be in the valley of love
and delight.
When true simplicity is gain'd,
To bow and to bend we shan't
be asham'd,
To turn, turn will be our delight,
Till by turning, turning we come
round right.

ANON, 19th century,
American Shaker song

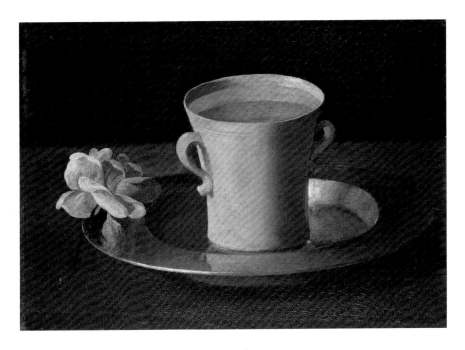

Francisco de Zurbarán, *A Cup of Water and a Rose*, about 1630

UNIVERSAL PRAYER FOR PEACE

Henri Fantin-Latour was the most celebrated 19th-century French painter of floral still life. These flowers appear so natural and so universal that it is easy to forget that what is being presented to us arises from a Western tradition of painting which is centuries old. There are traditions of painting, as there are religious traditions. They explore common experience and intimate that there is more to life than meets the eye. The styles and stories, the cultures and traditions differ but if there is a God they must point to the same God.

Go into almost any church, certainly St Martin's, and there are people who take great care to provide flowers. They are part of the offering to God which is our worship and our joy. In recent years the National Gallery has had a donor who has provided fresh flowers in the main entrance. They are welcoming and gladden the heart. No wonder an international network of florists tell us to 'say it with flowers' to those whom we love.

When I became the Vicar of St Martin's in 1995 I had no idea that creating worship in response to major acts of terrorism would be one of the most important things I would do. Terrorism destroys beauty. It seeks to divide and create mistrust, so in the immediate aftermath of 9/11 2001 and on a number of occasions since, including the London bombings of 7 July 2005, when the child of two members of our church was killed, we have held services in which people of different faiths have read their scriptures and prayed for peace. We have not sought to hide our differences, or that the context for these prayers is that of a hospitable Christian church, but we have found a deeper unity. The longing for peace is universal.

We can use these flowers and this universal prayer to help us find common ground with those who see God differently but with whom we share the beauty of the earth.

Lead me from death to life,
from falsehood to truth.
Lead me from despair to hope,
from fear to trust.
Lead me from hate to love,
from war to peace.
Let peace fill our heart,
our world, our universe.

Universal Prayer for Peace

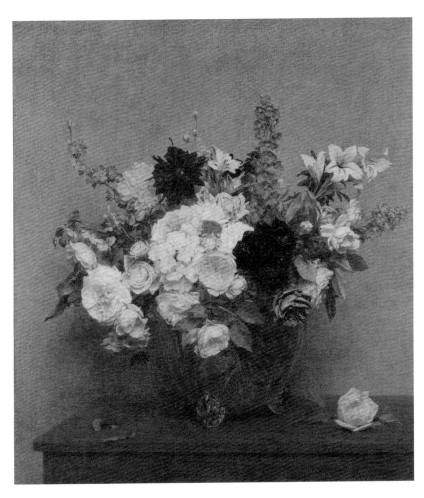

Ignace-Henri-Théodore Fantin-Latour, *The Rosy Wealth of June*, 1886

MOTHER

Few paintings in the National Gallery's collection are of poor people and their work, particularly of the work of poor women, especially before the 19th century. By taking an ordinary subject this painting extols the virtue of a wholesome and simple life without the complexity of wealth. A mother presides, feeding her family, who give thanks before meagre rations. In the foreground the dog licks the bowl. Nothing is wasted. The father has been set to work in the background. The door is open to the outside world and this family will find its way through it.

In Matthew 23: 37 and Luke 13: 34 Jesus compares himself to a mother hen gathering her chicks to keep them safe. It is one of relatively few feminine images of God from a predominantly masculine culture. This image recurs in Christian history. In our day, the recovery and development of feminine images of God feels striking and fresh as in this recent translation of a prayer by Saint Anselm.

Gather your little ones to you,
O God, as a hen gathers her
brood to protect them.

Jesus, as a mother you gather your people to you; you are gentle with us as a mother with her children. Often you weep over our sins and our pride, tenderly you draw us from hatred and judgement.

You comfort us in sorrows and bind up our wounds, in sickness you nurse us and with pure milk you feed us. Jesus, by your dying we are born to new life; by your anguish and labour we come forth in joy.

Despair turns to hope through your sweet goodness; through your gentleness, we find comfort in fear. Your warmth gives life to the dead, your touch makes sinners righteous.

Lord Jesus, in your mercy heal us; in your love and tenderness remake us.
In your compassion, bring grace and forgiveness, for the beauty of heaven, may your love prepare us.

SAINT ANSELM (1033–1109)
Archbishop of Canterbury
(1093–1109)
Translated by Michael Vasey,
Common Worship

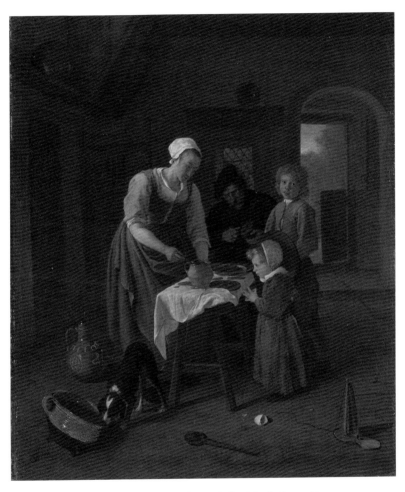

Jan Steen, *A Peasant Family at Mealtime* ('*Grace before Meat*'), about 1665

HOME

The quality of light and modesty of colours depict a peaceful and tranquil home created by women. It feels kindly and virtuous. The woman of this house is looking outwards through the door to the street, the interface with the world outside. Beyond this scene there is a man at work in the world providing for his family's safe home. The maid has stopped sweeping the courtyard to be with the child in what is evidently an affectionate relationship.

The stone tablet above the arch really exists and until recently it was set in a garden wall in Delft. The original, which was in a convent or monastery, says,

> This is St Jerome's vale if you wish to retire to patience and meekness. For we must first descend if we wish to be raised.

The painting and the inscription state that the meek patient life of service at home leads to heaven just as surely as a life of service in the wider world.

Visit, we beseech thee, O Lord, our homes, and drive away all the snares of the enemy; let thy holy angels dwell therein to preserve us in peace; and may thy blessing be upon us evermore; through Jesus Christ our Lord. Amen.

A prayer from Night Prayer or Compline

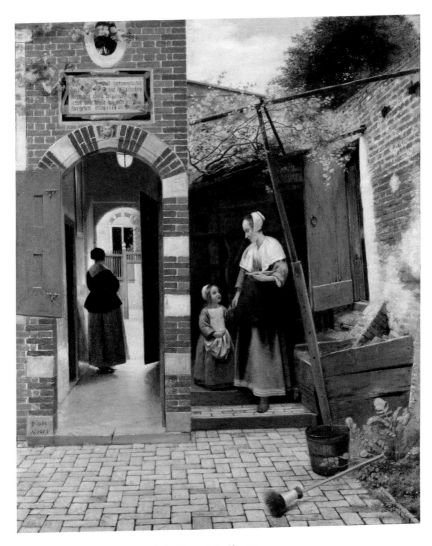

Pieter de Hooch, *The Courtyard of a House in Delft*, 1658

INTERIOR LIFE

Whenever you pray, go into your room and shut the door.

MATTHEW 6: 6

For Christians, time in solitude helps to give us:

'Easter eyes' able to perceive in death, life; in guilt, forgiveness; in separation, unity; in wounds, glory; in the human, God; in God, the human; and in the I, You.

Bishop Klaus Hemmerle (1929–1994)

The room is compact, the doors closed and the woman's back is turned to us so we cannot see her face or what she holds in her hands. This picture represents a private life; the woman's pose is out of keeping with our society obsessed with transparency and lives lived in public.

The desire to find spiritual direction has led to a growth in the number of people taking time out of their busy lives to make retreats to religious communities or places of prayer and solitude. There are two parts to this process: finding the way, and acting on it. The latter part is generally harder.

Eternal Light, shine in our hearts;
Eternal Goodness, deliver us from evil;
Eternal Power, be our support;
Eternal Wisdom, scatter the darkness of our ignorance;
Eternal Pity, have mercy upon us;
that with all our heart and mind and soul and strength
we may seek your face
and be brought by your infinite mercy to your
 holy presence,
through Jesus Christ our Lord. Amen.

Alcuin (730/740–804)

Grant us, Lord, we pray,
by the gift of your Spirit,
imagination in our thinking,
wisdom in our deciding,
and thoroughness in carrying
out what we have decided,
through Jesus Christ our Lord.
Amen.

DAVID DURSTON (b.1936)

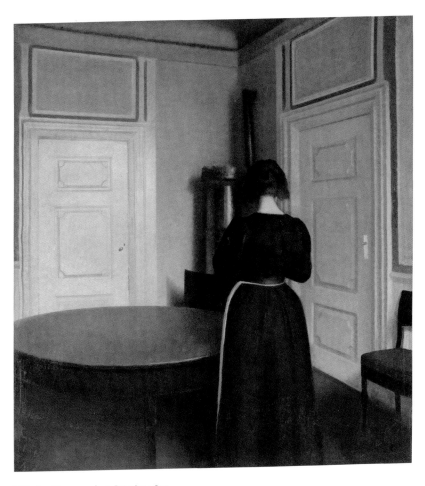

Vilhelm Hammershøi, *Interior*, 1899

TRUTH

Joseph Wright was the first painter of the Industrial Revolution. Air pumps had been known since the 1650s so this painting is not depicting a cutting-edge experiment but a science-based home entertainment. As the vacuum is created the poor cockatoo struggles to breathe. The scientist, with the power of God, could save it by releasing the valve at the top of the flask and the boy at the window is lowering the birdcage in anticipation. The father explains rationally what is happening to the distraught girl and the older man gazes on the skull lit by the candle. The young couple on the left are focused on each other. This is a meditation on science, reason and the meaning of life and death.

For Plato the beginning of knowledge is to wonder at things. In that spirit the true Christian is the true philosopher who loves and honours the truth. Theology has played a key role in the development of knowledge, education and the exploration of ideas. From the Enlightenment onwards questions emerged about whether science and religion are opposed or whether they are different discourses and methodologies, both of which are committed to seeking truth.

> I can take my telescope and look millions and millions of miles into space but I can lay it aside and go into my room, shut the door, get down on my knees in earnest prayer and see more of heaven and get closer to God than I can assisted by all the telescopes and material agencies on earth.
>
> Sir Isaac Newton (1643–1712)

Rationalism and secularism by themselves are inadequate reductionist accounts of life. The search for truth is multifaceted. Most people feel there is more to life than meets the eye and religious pluralism attests that to be human is to be religious.

From the arrogance that thinks it knows all truth,
from the cowardice that shrinks from new truth,
from the laziness that is content with half truth,
O God of truth, deliver us.

ANON

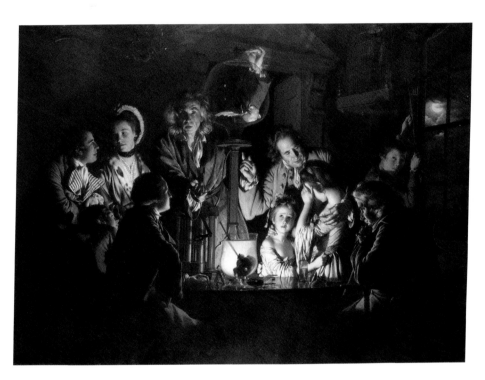

Joseph Wright 'of Derby', *An Experiment on a Bird in the Air Pump*, 1768

PRAISE

John Constable's father was a wealthy Suffolk mill owner. His brother commented that, 'When I look at a mill painted by John, I see that it will go round.' This attention to detail extends to the whole painting. Constable had learned from Benjamin West, the President of the Royal Academy of Art, who said:

> Always remember, sir, that light and shadow never stand still ... in your skies always aim at brightness ... even in the darkest effects ... your darks should look like the darks of silver, not the lead of slate.

The overall effect is a romantic and idealised rural life.

Admired by Constable's friends from the outset, *The Hay Wain* received an indifferent reception when first shown in London. It gave too much prominence to subjects not considered worthy of its size and scale, and was probably thought vulgar. It was sold in 1823 and exhibited in Paris where it was awarded a gold medal by Charles X. Now it is much loved as a romantic evocation of the English countryside.

Gerard Manley Hopkins was a Roman Catholic Jesuit priest whose poetry reflected the grandeur of God seen in nature.

GLORY be to God for dappled
 things –
For skies of couple-colour as
 a brinded cow;
For rose-moles all in stipple
 upon trout that swim;
Fresh-firecoal chestnut-falls;
 finches' wings;
Landscape plotted and pieced –
 fold, fallow, and plough;
And all trades, their gear
 and tackle and trim.

All things counter, original,
 spare, strange;
Whatever is fickle, freckled
 (who knows how?)
With swift, slow; sweet, sour;
 adazzle, dim;
He fathers-forth whose
 beauty is past change:
Praise him.

Pied Beauty, GERARD MANLEY HOPKINS (1844–1889)

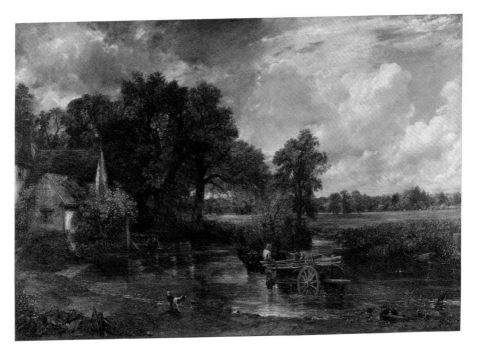

John Constable, *The Hay Wain*, 1821

DISTURB US, LORD

Two friends are depicted full size: Jean de Dinteville, the French ambassador to England, and Georges de Selve, Bishop of Lavaur, who visited London in 1533 and who on several occasions also acted as an ambassador. They are wealthy, educated, powerful and, at 29 and 25, astonishingly young men. Between them are symbols of their learning and of the issues of the day. This picture was painted at the height of the Reformation in England in which King Henry VIII was made Supreme Head of the Church of England in 1534. The theological rupture was international. The lute on the bottom shelf has a broken string and Luther's German hymn book is open at *Come Holy Ghost our Souls Inspire*, a prayer for the guidance of the Holy Spirit.

The large distorted skull at the feet of the ambassadors can only be seen clearly in perspective from the left edge of the painting. It stretches across a mosaic floor derived from a medieval pavement in Westminster Abbey. In this magnificent painting, Holbein is commenting that even very successful lives are short and we all have to live aware of our mortality. Finitude and judgement shake our complacency.

Disturb us, Lord, when we are too well pleased with ourselves, when our dreams have come true because we dreamed too little; when we arrive safely because we sailed too close to the shore.

Disturb us, Lord, when with the abundance of things we possess, we have lost our thirst for the waters of life; having fallen in love with life, we have ceased to dream of eternity, and in our efforts to build a new earth, we have allowed our vision of the new heaven to dim.

Disturb us, Lord, to dare more boldly, to venture on wider seas, where storms will show your mastery; where losing sight of land, we shall find the stars. We ask you to push back the horizons of our hopes, and to guide us into the future in strength, courage, hope and love.

Spirit of God, disturb, renew, encourage and guide us day by day. Amen.

Attributed to SIR FRANCIS DRAKE (1540–1596)

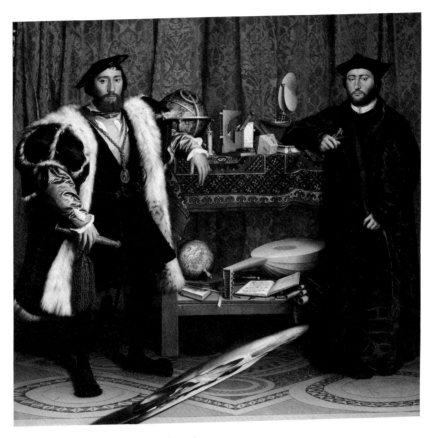

Hans Holbein the Younger, *The Ambassadors*, 1533

FUN AND DANGER

The acrobat Miss La La caused a sensation when she performed at the Cirque Fernando in Paris. She is shown by Degas in lurid artificial lighting suspended from the rafters of the circus dome by a rope clenched between her teeth. The angle is dizzying. It is an unusual subject for a painting as it is for prayer, but she is fully alive and radiates strength and beauty. According to Irenaeus, the 2nd-century Bishop of Lyons, 'The glory of God is a person fully alive.'

In ancient Rome the circus was for racing chariots and animals. In the modern circus acrobats play a major part. The performers often capture the imagination because of their skill and the risks they take in making what is difficult and dangerous appear easy and fun. 'It's a high wire act' is used to describe many who live a public life.

At the age of 25, Charles Dickens wrote a biography of Joseph Grimaldi (1778–1837), the original white-faced clown who was known as 'Joey the Clown'. Clowns have a melancholic side to them and Grimaldi used to joke, 'I am grim all day but I make you laugh at night.' Dickens tells of Grimaldi going to the doctor because he was feeling sad. The doctor suggested the best tonic would be for him to go to see the great Grimaldi who was sure to make him laugh. There was a long pause before the poor man replied, 'But I am Grimaldi.'

In 1883 Vincent van Gogh wrote a letter to Anthon Riddler in which he said,

> There is no writer, in my opinion, who is so much a painter and a black and white artist as Dickens. His figures are resurrections.

Flying like an angel and reaching for heaven, *Miss La La at the Cirque Fernando* extends our sense of what is possible and enlivening. It celebrates life and creates new worlds.

Methinks there is in God a well of laughter very deep.

ANON

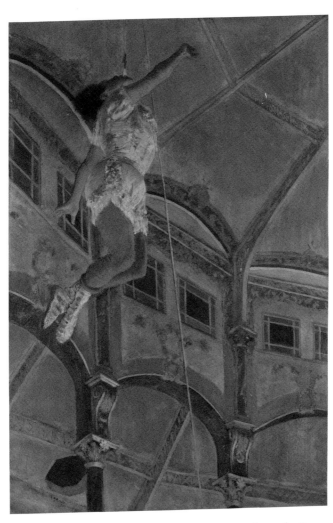

Hilaire-Germain-Edgar Degas, *Miss La La at the Cirque Fernando*, 1879

WOMEN ON THE EDGE

Horse fairs were run by people on the edge of society, a bit like the shepherds in the hills outside Bethlehem when Jesus was born. Horse fairs created some of the same feelings of anxiety and excitement in the more settled population, as when a fun fair comes to town. The power and attraction of the horses is palpable.

This is one of the very few paintings in the National Gallery's collection by women. Rosa Bonheur was the daughter of painters who were members of a Christian Socialist sect committed to the education of girls alongside boys. In the classroom she was disruptive and was expelled from several schools. Aged 12 her father took charge of her artistic education. The original of this reduced version of one of her best-known paintings is in the Metropolitan Museum in New York. It was painted with Nathalie Micas, for 40 years her lesbian partner.

The role of women and attitudes to homosexuals have changed greatly in the last century. Breaking new ground is difficult and people who do so are often treated as awkward and unwelcome. Jesus made his home with the poor, sick and outcasts; he spent time with women, Samaritans and tax collectors. These were people on the edge of society who were discounted, just as horse traders were. The UK's Chief Rabbi, Jonathan Sacks, has written about 'the dignity of difference', that we are incomplete without each other. In our day, South Africa has taught the world about creative diversity and breaking down the barriers that divide us. Being on the edge can be creative.

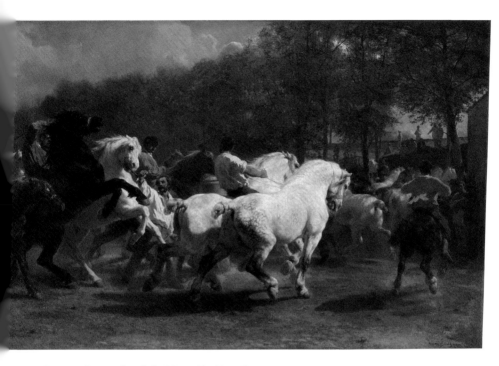

Rosa Bonheur and Nathalie Micas, *The Horse Fair*, 1855

Righteous God,
your Son will come to be our judge;
break down the barriers that divide us
and disperse our suspicions and hatred
that we may practise justice and mercy
and live together in peace;
through Jesus Christ our Lord. Amen.

Adapted from *An Anglican Prayer Book*,
Church of the Province
of Southern Africa, 1989

STRUGGLE AND BLESSING

Van Gogh was the son of a Dutch Protestant Pastor and his religious convictions were strong and intense. Once he had decided to become an artist, Van Gogh transferred his passion for religion to art.

Van Gogh travelled to Arles in Provence in 1888. The quality of light there encouraged him to paint in the vivid colours for which he is now remembered. A year later, he was admitted to the sanatorium at St Rémy because of a nervous breakdown. Shortly after his arrival at St Rémy he described the 'abandoned gardens' in which 'the grass grows tall and unkempt, mixed with all kinds of weeds.'

Through mental illness people often see reality vividly though, as T. S Eliot was to observe, humankind cannot bear very much of it. The path, perhaps the way out of Van Gogh's illness, looks distant at the top of this picture but the butterflies are a sign of hope, of new life and resurrection in the beautiful colours of the long grass. In 1890, suffering from a new bout of depression, Van Gogh shot himself in the chest and died two days later.

This prayer, the first five lines of which are attributed to American Protestant Reinhold Niebuhr, has been adopted by Alchoholics Anonymous. It is known as *The Serenity Prayer* but it is really the prayer of those who know the struggles of life and have come to find in them a blessing.

God, grant us grace to accept the things we cannot change, courage to change the things we can change, and wisdom to know the difference.
Living one day at a time, enjoying one moment at a time, accepting hardship as the pathway to peace;
taking, as He did, this sinful world as it is, not as I would have it;
trusting that He will make all things right if I surrender to His will;
that I may be reasonably happy in this life, and supremely happy with Him for ever in the next. Amen.

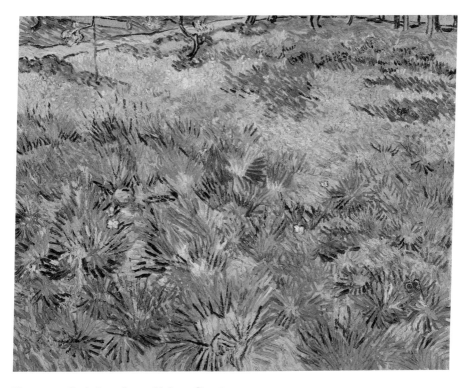

Vincent van Gogh, *Long Grass with Butterflies*, 1890

THANKSGIVING

These sunflowers almost dance with joy. They were painted in what for Vincent van Gogh was a rare mood of optimism, as he awaited the arrival of fellow artist Paul Gauguin at Arles in the south of France. The painting was a gift, to brighten Gauguin's bedroom and to encourage him to stay. Van Gogh longed to form an artistic community in Arles and for Gauguin to be its mentor. For Van Gogh, yellow represented happiness and this is just one of 11 pictures of sunflowers he painted. In Dutch literature the sunflower was a symbol of devotion and loyalty. In their various stages of decay, these flowers also remind us of the cycle of life and death.

Van Gogh experienced extreme mood swings and his life ended in tragedy. For him, as for Job in the Hebrew scriptures:

The Lord gives and the Lord takes away. Blessed be the name of the Lord.

Job 1: 21

Giving thanks to God for everything is a repeated theme in the scriptures, as it is in all traditions of prayer.

Almighty God, Father of all mercies, we your unworthy servants give you most humble and hearty thanks for all your goodness and loving kindness. We bless you for our creation, preservation, and all the blessings of this life; but above all for your immeasurable love in the redemption of the world by our Lord Jesus Christ, for the means of grace, and for the hope of glory. And give us, we pray, such a sense of all your mercies that our hearts may be unfeignedly thankful, and that we show forth your praise, not only with our lips, but in our lives, by giving up ourselves to your service, and by walking before you in holiness and righteousness all our days; through Jesus Christ our Lord, to whom, with you and the Holy Spirit, be all honour and glory, for ever and ever. Amen.

The General Thanksgiving
Church of England,
Common Worship, 2005
Adapted from *The Book
of Common Prayer*, 1662

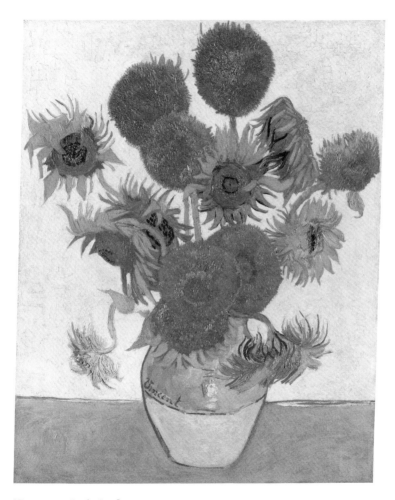

Vincent van Gogh, *Sunflowers*, 1888

AN EQUAL MUSIC

You can almost hear the music of the youngsters gathered round the warm candlelight. Hendrick ter Brugghen, from the Catholic city of Utrecht, had been to Rome and was impressed by the Italian artist Caravaggio, who used starkly contrasting light and dark to create drama in a painting. The influence of Caravaggio's style is obvious in this very Dutch concert party. The picture manages to evoke both a tavern and a pastoral idyll. A young boy sings, his eyes on the songbook lit by an oil lamp on the wall behind him. His hand beats time but the exotically dressed lute player and flautist both look out to catch our eye or invite us in.

This prayer is taken from a sermon preached by John Donne, Dean of St Paul's Cathedral, before King Charles I in the Palace of Whitehall in 1626/7 in what is now the parish of St Martin-in-the-Fields. The sermon and the painting are contemporaries. The painting is earthy with wonderful tones of light and shade. It knows darkness as well as joy. The prayer evokes eternity by the equality of light, music and hope in the home of God.

To live in the light of eternity is our task on earth.

Bring us O Lord God, at our last awakening into the house and gate of heaven, to enter into that gate and dwell in that house, where there shall be no darkness nor dazzling, but one equal light; no noise nor silence, but one equal music; no fears nor hopes, but one equal possession; no ends nor beginnings, but one equal eternity; in the habitations of thy glory and dominion world without end. Amen.

JOHN DONNE (1572–1631)

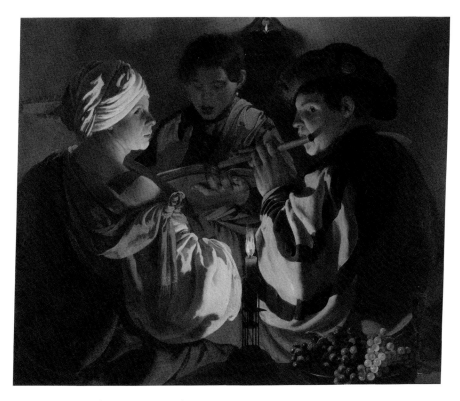

Hendrick ter Brugghen, *The Concert*, about 1626

OLD AGE

Although Rembrandt was a successful painter from an early age, he also knew sorrow first hand. Three children from his marriage to Saskia died in infancy. In 1642, shortly after the birth of a fourth child, Titus, Saskia herself died, probably of tuberculosis. A later relationship with Hendrickje Stoffels, his housekeeper and common-law wife, with whom he had a daughter, caused Hendrickje to be excommunicated by the Dutch Reformed Church. Hendrickje died in 1663 and Titus in 1668, a year before his father. It is hard to imagine anything more difficult for a parent than the death of a child, whatever their age.

Rembrandt earned a good income, notably from his work as a renowned portrait painter, but he lived beyond his means and in 1656 was forced into bankruptcy. He died on 4 October 1669 and was buried in an unmarked grave at the Westerkerk in Amsterdam.

Despite his reduced circumstances he continued to be productive. His sympathetic portraits of older people radiate inner strength from aged bodies. The many self portraits he etched and painted throughout his life are an intimate biography. In this particular portrait he presents himself in a reflective mood. Worn by life, he nonetheless confronts the viewer with a steady gaze. It is as if Rembrandt really is confident that old age is a time of fulfilment. He had found and accepted his vocation to grow old. This work was painted in the final year of Rembrandt's life and is one of his last pictures.

Grant, O Lord,
that the years that are left may
be the holiest,
the most loving,
the most mature.
I thank you for the past,
and especially that you have left
the good wine until now.
Help me to accept diminishing
powers and the opportunity to prepare
my soul for the full and free life to
come in the state prepared, by your Son
Jesus Christ our Lord. Amen.

AUSTEN WILLIAMS (1912–2001)
Vicar of St Martin-in-the-Fields
(1956–1984)

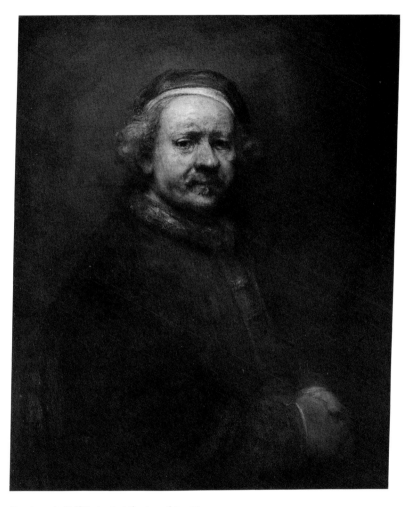

Rembrandt, *Self Portrait at the Age of 63*, 1669

THE PASSING OF AN AGE

The *Temeraire* was a 98-gun warship in Nelson's navy, built from 5,000 oaks and manned by 750 sailors. It is being towed up the Thames to the breaker's yard at Rotherhithe by a little tug, its funnel steaming and paddles turning. The sunset evokes the end of life, illuminating the old ship, its wood white, near death, like pale skin thin against its skeleton. *The Temeraire* is beautiful and stately in its old age. In reality its masts would already have been taken down but Turner has retained them so that the ship keeps its dignity. It has done its work well so that even in death it has grace and grandeur.

Turner's painting is a depiction of the passing of the age of the sailing ship, a meditation on death and bereavement. At about the time of Turner's painting, my predecessor as the Vicar of St Martin's, the Reverend Sir Henry Duckinfield, would have looked out on the building of the National Gallery (1833–7), Nelson's column (1840–3) and the completion of Trafalgar Square (1845).

The prayer by Sir Francis Drake, the scourge of the Spanish Armada and circumnavigator of the globe on the *Golden Hind*, encourages us to live for the true glory by continuing to the end.

The prayer by John Henry Newman comes from a sermon about the parting of friends and it was preached at Littlemore, on the edge of Oxford, on 19 February 1843, as Newman was leaving the Church of England to become a Roman Catholic. It is frequently adapted for use at funerals as a prayer for those who mourn and at evening prayer as the day closes.

O Lord God, when thou givest thy servants to endeavour any great matter, grant us also to know that it is not the beginning, but the continuing of the same, until it be thoroughly finished, which yieldeth the true glory; through him who for the finishing of thy work lay down his life for us, our Redeemer, Jesus Christ. Amen.

SIR FRANCIS DRAKE
(1540–1596)

May He support us all the day long, till the shades lengthen, and the evening comes, and the busy world is hushed, and the fever of life is over, and our work done! Then in his mercy may He give us a safe lodging, and a holy rest, and peace at the last. Amen.

JOHN HENRY NEWMAN
(1801–1890)

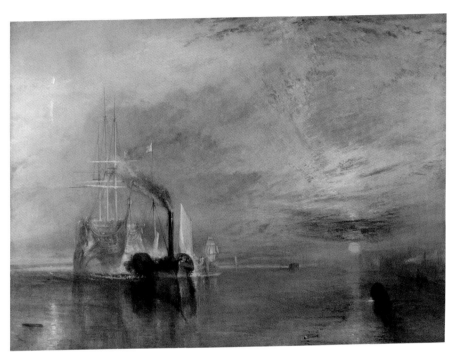

Joseph Mallord William Turner, *The Fighting Temeraire*, 1839

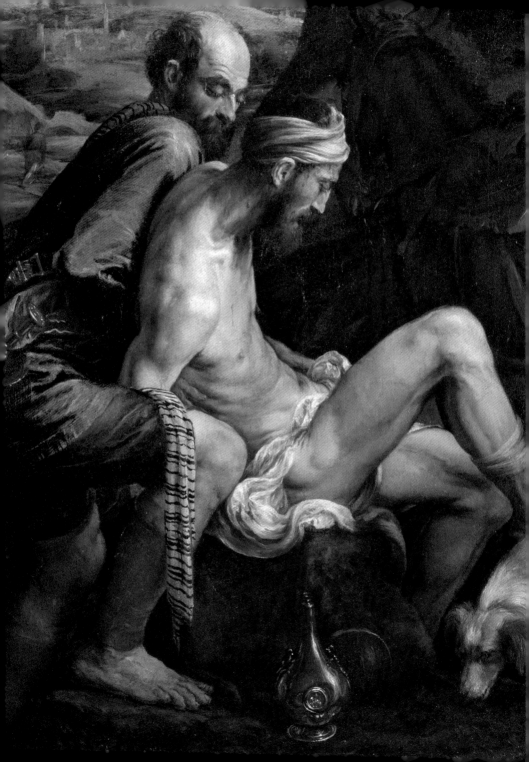

GOD BE IN MY HEAD

God be in my head, and in my understanding;
God be in mine eyes, and in my looking;
God be in my mouth, and in my speaking;
God be in my heart, and in my thinking;
God be at mine end, and at my departing.

Sarum Primer, 1558

THE GRACE

The Grace of our Lord Jesus Christ,
and the love of God,
and the fellowship of the Holy Spirit
be with us all, now and for ever. Amen.

BLESSING

Go forth into the world in peace;
be of good courage;
hold fast to that which is good;
render to no-one evil for evil;
strengthen the faint hearted;
support the weak;
help the afflicted;
honour all people;
love and serve the Lord,
rejoicing in the power of the Holy Spirit.
And the blessing of God almighty,
the Father, the Son and the Holy Spirit,
be upon you and remain with you forever. Amen.

Jacopo Bassano, *The Good Samaritan* (detail), about 1562–3

INDEX OF ARTISTS

Ordered by artist surname (in bold type)

INDEX OF AUTHORS

Ordered by author surname (in bold type)

LIST OF IMAGES

59 Duccio (active 1278; died 1318/19), *The Transfiguration*, 1311. Tempera on poplar, 44 × 46 cm.

61 English or French (?), '*The Wilton Diptych*', about 1395–9. Egg on oak, 53 × 37 cm. Bought with a special grant and contributions from Samuel Courtauld, Viscount Rothermere, C.T. Stoop and The Art Fund, 1929.

63 Francesco Solimena (1657–1747), *Saint Martin sharing his Cloak with the Beggar*, early 1730s. Courtesy the Vicar and Churchwardens, St Martin-in-the-Fields Church, London.

65 Sassetta (active by 1427; died 1450), *Saint Francis renounces his Earthly Father*, 1437–44. Egg tempera on poplar, 87.5 × 52.4 cm. Bought with contributions from The Art Fund, Benjamin Guinness and Lord Bearsted, 1934.

67 Pieter Saenredam (1597–1665), *The Interior of the Buurkerk at Utrecht*, 1644. Oil on oak, 60.1 × 50.1 cm.

69 John Constable (1776–1837), *Salisbury Cathedral from the Meadows*, 1831. Oil on canvas, 151.8 × 189.9 cm. On loan to the National Gallery, London, from a private collection.

71 Giovanni dal Ponte (about 1385–1437), *The Trinity: Centre Pinnacle*, about 1420–4?. Egg tempera on wood, 65.5 × 33.8 cm

75 Francisco de Zurbarán (1598–1664), *A Cup of Water and a Rose*, about 1630. Oil on canvas, 21.2 × 30.1 cm. Bought for the National Gallery by the George Beaumont Group, 1997.

77 Ignace-Henri-Théodore Fantin-Latour (1836–1904), *The Rosy Wealth of June*, 1886. Oil on canvas, 70.5 × 61.6 cm.

79 Jan Steen (1626–1679), *A Peasant Family at Mealtime ('Grace before Meat')*, about 1665. Oil on canvas, 44.8 × 37.5 cm.

81 Pieter de Hooch (1629–1684), *The Courtyard of a House in Delft*, 1658. Oil on canvas, 73.5 × 60 cm. Detail p. 73.

83 Vilhelm Hammershøi (1864–1916), *Interior*, 1899. Oil on canvas, 64.5 × 58.1 cm. On loan from Tate: Presented in memory of Leonard Borwick by his friends through The Art Fund 1926.

85 Joseph Wright 'of Derby' (1734–1797), *An Experiment on a Bird in the Air Pump*, 1768. Oil on canvas, 183 × 244 cm.

87 John Constable (1776–1837), *The Hay Wain*, 1821. Oil on canvas, 130.2 × 185.4 cm.

89 Hans Holbein the Younger (1497/8–1543), *The Ambassadors*, 1533. Oil on oak, 207 × 209.5 cm.

91 Hilaire-Germain-Edgar Degas (1834–1917), *Miss La La at the Cirque Fernando*, 1879. Oil on canvas, 117.2 × 77.5 cm.

93 Rosa Bonheur (1822–1899) and Nathalie Micas (about 1824–1899), *The Horse Fair*, 1855. Oil on canvas, 120 × 254.6 cm.

95 Vincent van Gogh (1853–1890), *Long Grass with Butterflies*, 1890. Oil on canvas, 64.5 × 80.7 cm.

97 Vincent van Gogh (1853–1890), *Sunflowers*, 1888. Oil on canvas, 92.1 × 73 cm.

99 Hendrick ter Brugghen (1588–1629), *The Concert,* about 1626. Oil on canvas, 99.1 × 116.8 cm. Bought with contributions from The National Memorial Fund, The Art Fund and The Pilgrim Trust, 1983.

101 Rembrandt (1606–1669), *Self Portrait at the Age of 63*, 1669. Oil on canvas, 86 × 70.5 cm.

103 Joseph Mallord William Turner (1775–1851), *The Fighting Temeraire*, 1839. Oil on canvas, 90.7 × 121.6 cm.

We have made every effort to identify the source of the prayers. If there are errors or omissions please notify the publisher and they will be corrected in any reprint. Biblical quotations are all from the New Revised Standard Version.

p.10: 'A Cosmic Prayer'. Text by Howard Georgi. ©2002 Wayne Leopold Editions, Inc. Used by permission.

p.18: extract from *The Heart of God: Prayers of Rabindranath Tagore*, trans. Herbert C. Vetter, 2004. By kind permission of Tuttle Publishing, a member of the Periplus Publishing Group.

p.24: prayer to 'Bless the Water of Baptism' from *Common Worship: Christian Initiation* © The Archbishops' Council, 2006. Used by permission. copyright@c-of-e.org.uk.

p.26: a prayer by Austen Williams, reproduced by kind permission of St. Martin-in-the-Fields.

p.30: 'General Prayer for Charity' by Charles Dickens, from *Westminster Prayers*, Percy Dearmer and F. R. Barry, 1936. By kind permission of the Dean of Westminster Abbey.

p.38: 'Victory is ours' prayer by Archibishop Desmond Tutu. Copyright © 1995 by Desmond Tutu used with permission.

p.42: taken from *Love's Endeavour, Love's Expense* by W. H. Vanstone, published and copyright 1977 by Darton Longman and Todd Ltd, London, and used by permission of the publishers.

p.46: 'Now the green blade riseth' by J. M. C. Crum (1872–1958) [altd]. First verse reproduced by permission of Oxford University Press. All rights reserved.

p.48: 'Prayer after Communion' from *Common Worship: Services and Prayers*, copyright © The Archbishops' Council, 2000. Used by permission. copyright@c-of-e.org.uk.

p.50: extract from *The Book of Common Prayer*, the rights in which are vested in the Crown, are reproduced by permission of the Crown's Patentee, Cambridge University Press.

p.52: extract from Dom Gregory Dix, *The Shape of the Liturgy*, 1945. By kind permission of Continuum International Publishing Group.

p.54: extract from *The Book of Common Prayer*, the rights in which are vested in the Crown, are reproduced by permission of the Crown's Patentee, Cambridge University Press.

p.62: St Martin-in-the-Fields 'Prayer for the World', by Geoffrey Brown and John Pridmore, reproduced by kind permission of St Martin-in-the-Fields.

p.82: prayer by Canon David Durston, by kind permission of Canon David Durston; prayer by Bishop Klaus Hemmerle, copyright Bistum Aachen (Germany).

p.93: Adaptation of Prayer for Justice and Peace from *An Anglican Prayer Book,* 1989, © Provincial Trustees of the Anglican Church of Southern Africa.

p.94: 'The Serenity Prayer': the first five lines of this prayer are attributed to Reinhold Niebuhr (1892–1971). The prayer is also associated with Alcoholics Anonymous.

p.96: 'The General Thanksgiving Prayer' from *Common Worship: Services and Prayers*, copyright © The Archbishops' Council, 2000. Used by permission. copyright@c-of-e.org.uk.

All images © The National Gallery, London, **except:**
p. viii © Suzanne Bosman
p. 11: The Royal Collection © 2011, Her Majesty Queen Elizabeth II
p. 63: © Courtesy of the Vicar and Churchwardens, St Martin-in-the-Fields Church, London
p. 69: © Private collection 2010 / Photo National Gallery, London
p. 83: © Tate, London, 2010.

AUTHOR ACKNOWLEDGEMENTS

Thanks to many friends and colleagues who have helped me to enjoy the paintings of the National Gallery. My colleagues at St Martin's occasionally illustrate a sermon with a painting and when our Children's Club escapes from the church service on a Sunday morning to go and look at paintings of Bible stories there is always a small exodus of adults with them. We are very grateful that the Gallery's education department also has an enlivening relationship with St Martin's homeless artists. On hearing about this project to make a Prayer Book for the National Gallery, quite a few of the congregation of St Martin's made suggestions about what might be included. I am grateful for all of them and apologise that the selection process means much that was good has been left out.

I particularly want to thank the staff of the National Gallery for their kindness and help in the preparation of this book. Sara Purdy was generous to invite me to write it and Claire Young was a perceptive and supportive enabler who also gave birth to her own child in the time it took to produce this book. Thanks to Rachel Giles and to Alysoun Owen and Jill Laidlaw for their skilful editing. In the time I have been Vicar of St Martin's the National Gallery has had three Directors: Neil MacGregor, Charles Saumarez Smith and Nicholas Penny. To say that each has been a very good neighbour to me and to St Martin's understates the significance of the relationship. Charles Saumarez Smith chaired the architectural selection panel for the buildings renewal of St Martin's. Neil MacGregor saw the possibilities for collaboration and friendship when I arrived in 1995. It was a friend of his, the Very Revd John Miller, who showed me that it was not just Biblical paintings that could be prayed.

For commenting on the draft of this book thanks to The Revd Professor Richard Burridge, Dean and Professor of Biblical Interpretation and to Canon Professor Ben Quash, Professor of Christianity and the Arts, both at King's College London; my friend the cartoonist and watercolourist Canon Philip Spence; and my colleagues at St Martin's especially the Revds Richard Carter and Katherine Hedderly. It is very much better for their input. Former colleagues were also wonderful at making suggestions and giving assistance, especially the Revds Liz Griffiths and Bernhard Schünemann. Thanks also to Rabbi Winer. Hugh Player, Allyson Hargreaves and Julie Emig from St Martin's were a great help. I am also grateful to the Bishop of London for reading the manuscript and writing a Foreword. He ends letters to his clergy, 'With thanks for our partnership in the Gospel'. It is a partnership for which I, too, am thankful.

NICHOLAS HOLTAM